Stiftung Insel
Hombroich

Grand Traiano
Art Complex

Benesse Art Site
Naoshima

White Cube, Green Maze: New Art Landscapes

White Cube, Green Maze:
New Art Landscapes

Raymund Ryan

With contributions by Brian O'Doherty and Marc Treib
With photographs by Iwan Baan

The Heinz Architectural Center
Carnegie Museum of Art
Pittsburgh

University of California Press
Berkeley, Los Angeles, London

Published on the occasion of the exhibition *White Cube, Green Maze: New Art Landscapes*, at the Heinz Architectural Center, Carnegie Museum of Art, Pittsburgh, September 22, 2012–January 13, 2013.

Travels to Yale School of Architecture Gallery, February 18–May 4, 2013

Major support for the catalogue was provided by Elise Jaffe + Jeffrey Brown. The programs of the Heinz Architectural Center are made possible by the generosity of the Drue Heinz Trust. General operating support for Carnegie Museum of Art is provided by The Heinz Endowments and Allegheny Regional Asset District. Carnegie Museum of Art receives state arts funding support through a grant from the Pennsylvania Council on the Arts, a state agency funded by the Commonwealth of Pennsylvania.

University of California Press, one of the most distinguished university presses in the United States, enriches lives around the world by advancing scholarship in the humanities, social sciences, and natural sciences. Its activities are supported by the UC Press Foundation and by philanthropic contributions from individuals and institutions. For more information, visit www.ucpress.edu.

Library of Congress Control Number: 2012937375
ISBN: 978-0-520-27440-2

Published by

Carnegie Museum of Art
Pittsburgh, Pennsylvania
4400 Forbes Avenue
Pittsburgh, Pennsylvania 15213-4080
www.cmoa.org

University of California Press
Berkeley and Los Angeles, California

University of California Press, Ltd.
London, England

For Carnegie Museum of Art
Katie Reilly, Head of Publications
Laurel Mitchell, Coordinator of Rights and Reproductions
Emily Rice, Special Projects Assistant
Krystina Mierins, Curatorial Assistant

For University of California Press
Kari Dahlgren, Sponsoring Editor
Eric Schmidt, Editorial Coordinator
Pam Augspurger, Production Coordinator

Designed by MGMT. design
Edited by Katie Reilly

Printed in China by Asia Pacific Offset

20 19 18 17 16 15 14 13 12 11 10 9 8 7 6 5 4 3 2 1

Contents

Acknowledgments

White Cube, Green Maze: New Art Landscapes began as a lecture at Lismore Castle in Ireland. The lecture was inspired by Lismore itself, with its special synthesis of natural beauty, layers of architectural invention (Joseph Paxton; A. W. N. Pugin), and openness to contemporary art. I thus owe warm thanks to William and Laura Burlington for their wonderful hospitality in Ireland, and to Aileen Corkery for having put things in motion.

Now, some years later, I am happily indebted to Brian O'Doherty and Marc Treib for their erudite texts and to the extraordinary photographer Iwan Baan, who has visited all six sites included in the exhibition and contributed the vivid contemporary photographs that are so critical to the spirit of this catalogue.

The realization of *White Cube, Green Maze: New Art Landscapes* is indebted to the curators, architects, artists, and landscape architects for all six institutions included in this catalogue. For Seattle: Marion Weiss, Michael Manfredi, and Allison Wicks in New York; and Marisa Sánchez at the Seattle Art Museum. For Hombroich: Wilhelm Petzold, Ulrike Rose, and Oliver Kruse at Insel Hombroich; Álvaro Siza Vieira in Porto; Rudolf Finsterwalder in Stephanskirchen; Roland Eckl in New York; and Wilfried Wang in Berlin. For Naoshima: Takafumi Shimooka at the Naoshima Fukutake Art Museum; Tadao Ando, Yumiko Ando, Gonzalo Velez, and Gen Machida in Osaka; Hiroshi Sambuichi and Masashi Shigenaga in Hiroshima; Ryue Nishizawa and Yumiko Tokuno in Tokyo; the Tomio Koyama Gallery in Tokyo; Kazuhito Yoshii in New York; and Dung Ngo in New York. For Inhotim: Rodrigo Moura and Júlia Reboucas at Inhotim; Carlos Alberto Maciel in Belo Horizonte; Maria Paz in Belo Horizonte; and Rodrigo Cerviño Lopez in São Paulo. For Culiacán: Tatiana Bilbao in Mexico City; Lara Becerra and Emiliano Garcia in Mexico City; and the Colección Isabel y Agustín Coppel in Culiacán. For Grottaferrata: Pierpaolo and Valeria Barzan in Rome; Sharon Johnston, Mark Lee, and Nick Hofstede in Los Angeles; both Simons (Hoffmann and Frommenwiler) in Basel; and Lorenz Dexler in Berlin.

The graphic design of both the catalogue and exhibition for *White Cube, Green Maze: New Art Landscapes* is the work of Brooklyn-based MGMT, in particular Alicia Cheng, Sarah Gephart, and Erola Boix. We would like to thank Kari Dahlgren and her team at the University of California Press for their enthusiastic support of the publication. I am furthermore indebted to Laurel Mitchell, coordinator of rights and reproductions, and to Katie Reilly, our always constructive head of publications.

Essential to the project was the support of Maureen Rolla, deputy director; and Lynn Zelevansky, the Henry J. Heinz II Director, who has encouraged us to be ambitious and strategic in all we do.

I also wish to thank director of exhibitions Sarah Minnaert, who has skillfully kept this project focused in all the right directions; exhibitions associate Heather Ernharth; exhibitions assistant Jeff Lovett; Chris Craychee and the entire workshop team; Monika Tomko and her team of registrars; curator of education Marilyn Russell; chief conservator Ellen Baxter; Jonathan Gaugler, communications manager; Nick Pozek in technology initiatives; Lenora Vesio, director of development; and my fellow curators Linda Benedict-Jones, Dan Byers, Jason Busch, Tina Kukielski, and Louise Lippincott.

Special thanks are due to Krystina Mierins, former curatorial assistant at the Heinz Architectural Center, who helped on many early aspects of the exhibition and catalogue, including initial drafts for the project texts. Philip Denny, from the Carnegie Mellon School of Architecture, brought his computer design skills to help organize the installation. Thanks are due to Alyssum Skjeie, curatorial assistant, and to my fellow curator at the Heinz Architectural Center, Tracy Myers.

I have had the great fortune to avail of the talents and dedication of Emily Rice for the last year. As special project assistant, Emily has ensured that the many disparate components of *White Cube, Green Maze* have somehow all come together.

Ultimately this publication is due to the generosity of Elise Jaffe and Jeffrey Brown, two extraordinary benefactors of contemporary architectural culture. To Elise and Jeffrey, we are—once again—extremely grateful.

Raymund Ryan
Curator of Architecture
The Heinz Architectural Center

Director's Foreword

As the Heinz Architectural Center approaches its twentieth anniversary, it seems especially apt that, in an institution with a broad purview like Carnegie Museum of Art, curator Raymund Ryan should investigate a subject of contemporary interest not only to many leading architects around the world but also to museum curators, artists, and landscape architects.

White Cube, Green Maze: New Art Landscapes presents six venues in very different parts of the world, sites that lie thousands of miles from each other but share similar ambition in the presentation of art. Each unites an interest in environmental sustainability, innovative architecture, and new modes of art-making and display, suggesting the possibility of an emerging trend that could transform the meaning and experience of museums. If we remove art from the grand architectural monuments in which it is usually publicly housed, does it become imbued with the kind of life that it has in the artist's studio or some equally informal space? Could the merging of forms represented in *White Cube, Green Maze* signal the waning of the trophy museum? Is this kind of site possible only because globalization shrunk our world? The exhibition poses these and other fascinating questions.

Our first thanks for the support of *White Cube, Green Maze* must go to the founding patron of the Heinz Architectural Center, Drue Heinz, who, through The Drue Heinz Trust, underwrites HAC's ongoing activities, supporting its staff, exhibitions, and collections. As we approach our twentieth anniversary, we salute Drue Heinz for her farsightedness and generosity.

White Cube, Green Maze travels from Pittsburgh to the Yale School of Architecture; we very much appreciate Dean Robert Stern's early recognition of the of the relevance of this exhibition and his partnership in this endeavor.

The forces behind each of these sites—patrons, curators, and administrators—were essential for providing us with access, research, and, of course, objects for the exhibition. We are very grateful to them, to the great architectural photographer Iwan Baan for his beautiful work, and to all the lenders to the exhibition. Without their generosity, it could never have happened. We thank them for their collaborative spirit. We are particularly grateful to Elise Jaffe and Jeffrey Brown for their generous contribution toward this catalogue.

Kudos to Ray Ryan, who is responsible for the ideas behind, and execution of, *White Cube, Green Maze*. He and his team at the Heinz Architectural Center have made a unique and important contribution to the field.

Finally, we must all be grateful to the architects, landscape architects, and artists whose work is highlighted in this show. Their art inspires us.

Lynn Zelevansky
The Henry J. Heinz II Director
Carnegie Museum of Art

A New Museum Ecology?

Brian O'Doherty

The axis of museum architecture is easily, if somewhat glibly, traced. The Beaux-Arts temple, which elevates the mind, intimidates the unsophisticated, comforts the wealthy. John Russell Pope's National Gallery in Washington, DC, dedicated in 1941, serves as a late example. This was succeeded by the International Style box, with obligatory curtain wall, the visitor a messy organic intrusion into its sanitized space—Ludwig Mies van der Rohe's Museum of Fine Arts, Houston, will do. Then there was a fortunately brief, somewhat hysterical fit of retro, abounding in strange excrescences. Presently, we find the free play of the architects' imagination, empowered by new technology, in which the museum can itself be a masterwork competing with the artists' visions within. Frank Gehry's Bilbao is the signature emblem, displacing Frank Lloyd Wright's Guggenheim, the eccentricity of which convinced many artists that architects would never understand their needs.

All these examples share a desire for the building as redemptive, to stand, as successful institutions do, for values shared, protected, and represented. The museum's mission was storage and educated resuscitation of the past and the presentation of exhibitions mirroring the mutating present. However dazzling the outside—soaring wings, grand terraces, sine-curve extravaganzas—the inside remains through all these phases as stable as a bank vault. The galleries, which I have called "white cubes," remove all references to the outside. The art is in a blanched isolation ward, tended by curators, restorers, and presenters. You could follow this medical notion too far ("art as precious invalid").

If the white cube stands for anything, it is, despite the frenzy of education that surrounds it, emblematic of the separation of art from common discourse, from the street, from life as lived amid dirt, cars, trucks, noise, and a quite perilous social contract. Is this a cause for complaint and moralizing? Not really. Large segments

of our culture get along fine without art—never missed it. I'll avoid (in contrast) citing the virtues of vernacular cultures: from invention of language (slang), to the unexpected establishment of public place (Holly White's researches), to the various perceptual sophistications (street-smarts) in which the city dweller becomes proficient. That's where life is, and the museum can be seen as a contemplative oasis where what you put into looking gives back more—or used to be, until the major museums became inundated with fluctuating crowds, the art became fetishized, and the experience compromised.

A huge body of museum literature ponders what a museum is, should be, how it "adjusts to the present." In terms of its support and governance, it mirrors our corporate culture. While wonderful thinking has been applied to its complexities, there is a lack of radical ideas (a rare example being Palle Nielsen's disruptive children's exhibition at the Moderna Museet in Stockhom, 1968), of drastic reforms, of solutions that avoid the idealism that seems to have a faint taint of contempt for the public and disrespect for the art (one frankly dystopian example: pipe the unsophisticated overflow into a museum of perfect reproductions next to the "real" museum).[1] Radical ideas tend to die since society has an endless talent for cooption (there are too many easy targets here, and no easy solutions). Advances—if they are advances—are made incrementally. But one master principle is always true: The container determines how the art within its cluster of stable white cubes is seen, experienced, and remembered.

The six examples assembled here propose alternatives to the standard museum visit in a crowded metropolis. Do museums make good neighbors? Perhaps no more than sports stadiums do, or urban universities, which have a founding imperative to metastasize. Museums require space "for expansion," but that desire is compressed by irate neighbors (the Whitney Museum of American Art's frustrated attempts at expansion) or by unlicensed transgression into the public space (the Metropolitan Museum of Art's expansion into Central Park).

For these six projects in six countries, generous space is available, in environments and contexts that stimulate the imagination—islands, parkland, a postwar landscape, the edge of a desert, a hill town, and a city edge traversed by train tracks and a road producing contrary arrow-shapes of little intrinsic beauty, this last a sculpture park. Such parks are always problematic. Conflicting aesthetics jostle each other. How can each work be given its context, its approach, its serial

disclosure in the round? The example of a well-bred studio sculpture posed in front of an International Style office building (which has been compared to encountering a Vassar girl working the street) seems to have phased itself quietly out. There are not that many "big" sculptors left. The best parks are for a single artist/sculptor. Unsuccessful sculpture parks look like trailer parks, without the trailer park's vernacular integrity.

All six projects marry landscape architecture and architects. Nature, that ravished survivor of our depredations, is restored, cultivated, put to work. The theme is twofold: the dispersal of the monument, the architectural icon that confines the art in a generally windowless fortress; and the relaxed distribution of that museum's massive structure into pavilions and landscapes where the visitor—that enigmatic and mutable organism—can stroll, search out, engage or not engage, and generally play as the spirit (of curiosity, of inquiry, of enjoyment) moves him or her.

This is as much a redefinition of the viewer as the museum, and it is the viewer, that wandering biped, that has received an enormous amount of attention in recent years. The viewer is now surrounded by a body of ideas called "reception theory," and that in turn returns us to how the art is presented and the theories that underlie that (Victoria Newhouse's careful researches here are invaluable).[2] There are precedents mentioned here—Louisiana Museum of Modern Art in Denmark, the Kröller-Müller Museum in the Netherlands (see Ryan, figures 5–6)—and one cannot pass on without mentioning the unique cultivation of landscapes, vistas, and gardens (eighteenth-century English, Japanese) that put the viewer in the paintings that are on offer within at the Huntington Library, Art Collections and Botanical Gardens near Los Angeles—a conceit of extraordinary tenacity and requiring the most ambitious maintenance. This compendium of landscapes reflects the displays inside the museum of national arts—Dutch, Spanish, and so forth. This distinction is literalized in the J. Paul Getty Museum in Los Angeles, where the art of each country, like a frozen Venice Biennale, is self-contained; you have to walk through blinding light (and occasional downpours) across bald communal space (a kind of museum agora?) to the art of the next country.

Inside and outside, the Shem and Shaun of all buildings, are always at hand when speaking of museums and indeed of any organism. The museum's inside, with its serial white spaces, indeed its white maze, is a constant that has, I suspect, durability beyond our lifetimes, broken only by the occasional disruptive installation, trashing the white space. The gallery spaces need have no (or limited)

relation to their enclosing structure—at least so I was told by an architectural scholar, and that was a shock. There perished another article of my faith—that the inside and outside of buildings had a reciprocal and necessary relationship. Trained in biology, I noticed that one of the models that architecture occasionally used was the body. Its packaging of multiple organs in economic spaces is, it seems to me, neat, effective, functional, and mildly didactic—and not just organs, but systems, contiguous as tightly parked cars, each separate in their function and each working uncomplainingly at their job. This constellation of systems is serviced by a common circulation and nervous system, enclosed by the body's largest organ, skin.

That model went out long ago, succeeded by the linguistics of structure and space and the influence of new technology ("free at last" of gravity) and—this is not said often enough—of minimal artists and sculptors from the sixties and seventies, the time when architectural daring gave itself unlimited license. We could now think that buildings, like art, could summon irony, quotation, skewed perspective, redundancy, even satiric design. It seems as if Robert Venturi's polemic of the sixties has now finally taken effect (though Venturi perhaps did not particularly influence himself).[3] Usually, polemics have a hard competitive edge. What is remarkable about the six projects explored here is their gentleness, their accommodating dignity, their desire to please, their restrained urge to invent self-satisfied buildings, and their respect both for the art and its audience, the latter conceived not as a congealed blob but as civilized, strolling, perceptive, and unthreatened individuals.

This is due, I think it's clear, to the conception of each project as a shared and cooperative venture in which nodes of activity are dispersed through the landscape, which is itself encouraged to illuminate unpretentious structures. Is this a new museum ecology? Most definitely. The prerequisites are space, the submission of two disciplines to a common goal—serving the art, artist, and public in situations that, as far as my amateur eye can read the plans, offer multiple options and seem united in a pleasurable creative arc. As Raymund Ryan has put it, "not only the integration of vegetation but a non-linear sequence of spaces. The space between the buildings is as important as the buildings themselves. In this hierarchical breakdown, nature returns."

1 See Lars Bang Larsen, *Palle Nielsen: The Model; A Model for a Qualitative Society (1968)* (Barcelona: MACBA, 2010).

2 See Victoria Newhouse, *Towards a New Museum* (New York: Monacelli Press, 2007).

3 See Robert Venturi, *Complexity and Contradiction in Architecture* (New York: Museum of Modern Art, distributed by Doubleday, Garden City, NY, [1966]).

White Cube, Green Maze:
New Art Landscapes

Raymund Ryan

A defunct oil storage depot in the Pacific Northwest. A former NATO missile base in Germany. An archipelago of Japanese islands partially used for industrial purposes. These and other unorthodox sites—to various degrees awkward, abandoned, peripheral, even remote—are today home to experiments in the production, presentation, and interpolation of culture.

It typically requires a concerted effort to visit these new landscapes, to make tangents or detours from the established trajectories of the art world and of global tourism. A visit to these new sites is a journey, perhaps even a pilgrimage. The destinations inspire not only our exploration of art but a new appreciation of topography, ecology, botany, and the hybrid natural/artificial world in which most of us live today.

A farmstead in Brazilian mining country re-envisaged by a great landscape architect and young architectural talent. A botanical garden in Mexico resuscitated by ecological strategies, engaging art, and sensuously minimal architecture. A dowager villa in an Italian hill town animated by a necklace of satellite pavilions. The effect of these transformations is to achieve new terrains for art that are as much constructed landscapes as they are museums in any traditional sense.

These multipart plans invite us to roam, to meander, to discover. The visitor is presented with options, with many routes and with many experiences, both sensory and intellectual. Unlike the monumental museum favored by many Beaux-Arts and High Modernist architects, this architecture is not monolithic. These buildings do not speak with a single deductive and authoritarian voice. In fact there may be several pavilions or residual buildings, structures that frame or suggest space as much as occupy it, or that are designed by quite different architects.

This new attention to external space, topography, and vegetation reflects a growing environmental awareness worldwide. We don't have to constantly reinvent the world; that's unsustainable, both materially and psychologically. Our critical faculties are increasingly engaged with and nourished by sites with some sense of place, of memory and character. Today art and its enjoyment seems better accommodated by less rhetorical design than that favored in times of excess, by environmental design that appeals to all our senses.

Indeed, much contemporary art is no longer suited to the traditional museum typology. In particular, installation art may be unduly big, messy, awkward, and overpowering for standard museum models.

Around the world, new institutions are dedicated to architecture, landscape, and radical art with no one aspect of that trinity—architecture, landscape, art—paramount; the Olympic Sculpture Park in Seattle, the Stiftung Insel Hombroich in Germany, Benesse Art Site Naoshima and adjacent islands in Japan, Instituto Inhotim in Brazil, Jardín Botánico de Culiacán in Mexico, and the Grand Traiano Art Complex near Rome present evidence of this trend in the most focused or fullest manner.

Each in its own way is an evolution from the white cube gallery of the 1960s through the brownfield, postindustrial experiments of the 1980s to a new understanding that balances old and new, the organic and the inorganic, local and global, the singular and the collective. They fuse architecture, the reuse of found structures, environmental consciousness, and artistic experimentation.

FROM WHITE CUBE TO BROWNFIELD

The twentieth-century gallery, minimalist and often hermetic, was brilliantly critiqued by the artist and critic Brian O'Doherty in *Inside the White Cube: The Ideology of the Gallery Space*. This paradigm has remained at the forefront of curatorial practice since O'Doherty's lectures at the Los Angeles County Museum of Art in the mid-1970s and their publication in book form a decade later.

In the 1980s and 1990s, many brownfield or postindustrial sites were appropriated as raw exhibition spaces, with museum directors and city politicians frequently dangling the prospect of economic revival to struggling communities (The Bilbao Effect). In recent years, as the art market has expanded in scale and reach to include China, India, Brazil, and other surging economies, dealers, curators, and collectors have begun to bring contemporary art to far-flung, frequently novice locations. Will the resultant spatial design merely mimic established Western paradigms or can other models emerge for the display and nurture of radical art?

Many impressive new sites for art might be dubbed "green mazes," as the term signals not only the importance of vegetation and nature but also a non-linear sequence of spaces. In fact, the progression in museum thinking might best be characterized as "white cube, brownfield, green maze." Many of these projects—Seattle's Olympic Sculpture Park, for example, or the Raketenstation at Hombroich in Germany— evolve from a context of deindustrialization into new forms of green space; green both in the sense of parkland (chlorophyll) and of environmental sustainability.

The year 1997 saw the inauguration of two markedly different high-profile art museums. One, the Getty Center (its museum merely one part of a complex program), was designed by Richard Meier as a white cubistic village on the hills above Los Angeles. It exudes in every direction that architect's meticulous concern for geometric coordination. The other museum, the Bilbao Guggenheim in Spain's Basque Country, was designed by Frank Gehry as an inhabited sculpture of exuberant forms, a visual tease amid the bridges, river banks, and canyonlike streets of its postindustrial host city.

Both projects are paradigmatic. The Getty is the culmination of Meier's analysis of the oeuvre of Modernists such as Le Corbusier, a solution nearing perfection on its own terms. Meier's technological precision may ultimately prove less influential than his strategy of collage. Conversely, the Guggenheim heralded a dramatic new direction for architecture enabled by then-nascent computer programs. The Getty revisited a favorite architectural allusion: the cluster of self-similar forms. The Guggenheim radicalized the museum design game: suddenly cities worldwide vied for similarly iconic attractions.

If the Getty represents an apotheosis of the white cube museum and if the Guggenheim, albeit unintentionally, launched the "starchitect" phenomenon, another strand

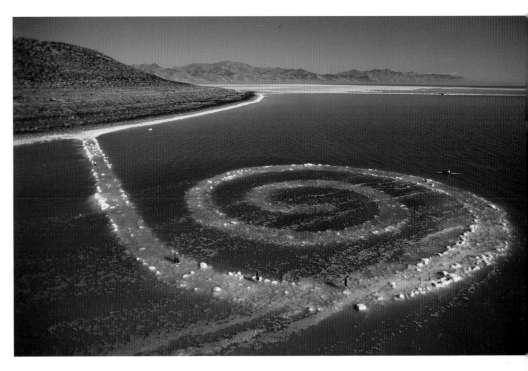

of museum building was heralded by a very different Frank Gehry project in the early 1980s: his conversion of a police vehicle depot in Downtown Los Angeles into the Temporary Contemporary (now the Geffen Contemporary) for the Museum of Contemporary Art. This minimal intervention into an industrial facility favors the presentation of multidimensional, multimedia, and often temporary installation art.

A similar strategy of reuse was present at the same time in London, where Max Gordon housed the first iteration of the Saatchi Collection in a former paint warehouse off Boundary Road. John Russell, in the *New York Times*, called it "a thinking man's maze."[1] This fusion of the white cube and the postindustrial envelope achieved wildly popular success with the conversion by Herzog & de Meuron of the mostly decommissioned Bankside power station into London's Tate Modern in 2000.

Postindustrial space became *de rigueur* for museum architecture. Institutions could find generous floor area and volume at affordable prices. Enterprising artists had long before moved into industrial premises, producing work inspired by and scaled to these factories, workshops, warehouses, and hangars. Where artists go, galleries and museums and the entire panoply of modern consumerist culture now follow. New York's SoHo is an egregious example of this transfusion of an entire neighborhood or urban quarter. Soon London's East End, post-reunification Berlin, and Beijing's Dashanzi Art District exhibited similar symptoms and shifts in perception.

Concurrent with this pioneer impulse for artists to desert the pristine white cube for urban grit was a seemingly contradictory phenomenon as countryside and wilderness began to exert a new appeal. In late 1960s America, artists had begun to travel far from the urban art market to make work—Land Art—in Utah, New Mexico, Nevada, and Arizona. Robert Smithson's *Spiral Jetty* and James Turrell's slow manipulation of Roden Crater, an extinct volcano, are among the better known examples (figure 1).

↓ Figure 2: Donald Judd, interior of artillery sheds housing 100 untitled works in mill aluminum, 1982–1986, Chinati Foundation, Marfa, Texas

Figure 3: View of Long Studio by Todd Saunders Architecture, 2010, Fogo Island, Newfoundland

↓ Figure 4: View of *Apollon Terroriste* in the Wild Garden at Little Sparta, Ian Hamilton Finlay's estate near Edinburgh, Scotland, developed over twenty-five years starting in 1966

Figure 5: Exterior of Louisiana Museum of Modern Art by Jørgen Bo and Vilhelm Wohlert, 1958 onward, Humlebæk, Denmark

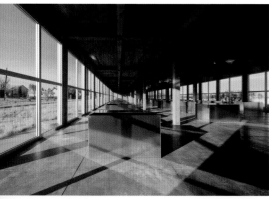

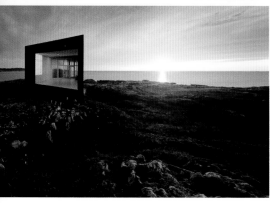

Donald Judd essentially resurrected a rural town—Marfa, Texas—and changed it into a point of pilgrimage. Blessed with beautiful skies, the remote railroad town was gradually infiltrated by artists and fellow travelers to become a new kind of Mecca for contemporary culture. In the 1980s, Judd oversaw the reuse of Fort D. A. Russell, a military fort with an array of single-story sheds, for the large-scale installation of his art and that by close colleagues (figure 2). Like the Raketenstation at Hombroich, this brownfield is a legacy from the mid-century military-industrial complex.

Something similar to Marfa may be occurring today on Fogo Island, a remote outcrop off the coast of Newfoundland (figure 3). A native islander, Zita Cobb, is using a fortune acquired in high technology to fund the construction of studios for visiting artists and an inn. All-white boxes—the eternal return of the cube—or black boxes with startling white interiors, are designed by Todd Saunders, a Canadian architect based in Norway. Fogo Island is not, or not yet, a museum. Nevertheless, the impetus there is to use design and culture to bolster a sagging economy in an area of dramatic natural beauty.

In Europe in the 1960s and '70s, artists also moved out of the museum to work in nature and in everyday contexts. In Scotland, Ian Hamilton Finlay worked on his own garden, Little Sparta, placing sculptures often with classical allusions and exhortations amid the plants and ponds (figure 4). Such artists remind us that art can find a home far from official sanction.

We may today be in a period of museum fatigue, of oversaturation by images of attention-seeking architecture. The new focus on nature and landscape—the green maze—may in part be a reaction to the excesses of recent institutional ambition. Several largely new institutions—Inhotim, for example, in the Brazilian state of Minas Gerais—are embedded in the countryside, requiring concerted effort on the part of most visitors and raising consciousness of not only art but land use and environmentalism.

PAVILION MUSEUMS

Today several canny institutions are working to adapt existing structures or infrastructure; others modify natural terrains or land masses liberated from industrial processes. The architecture of these new museums is frequently residual, or reactive to existing conditions and immediate neighbors. These campuses for art offer choice, require exploration, and instigate promenade.

Such landscapes are not sculpture parks in the strict twentieth-century mode, as elegantly exemplified by Storm King outside New York City (see Treib, figure 5) or Yorkshire Sculpture Park in the north of England. It is no longer simply a matter of placing sculpture on grass. Instead, these newer institutions extend and enrich a heritage of pavilion museums such as the Louisiana Museum of Modern Art north of Copenhagen and, in a surprisingly rustic quarter of the Netherlands, the Kröller-Müller Museum near Otterlo.

Louisiana was established in 1958 by Knud Jensen. His architects, Jørgen Bo and Vilhelm Wohlert, constructed a chain of orthogonal structures connected by glazed links. The design is low-key, prioritizing topography, light, and views to the nearby water. The landscape architects, Ole and Edith Nørgaard, developed a sequence of outdoor rooms and terraces (figure 5). Jensen has described the genesis of Louisiana as in part a reaction to Denmark's Royal Museum in the early 1950s: "a true horror cabinet...huge, fat columns, a broad forbidding marble staircase, rows and rows of plaster busts, dark alcoves."[2] When he purchased the estate at Louisiana, Jensen

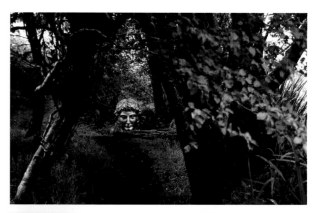

↓ Figure 6: Exterior of the Rietveld Pavilion by Gerrit Rietveld, reconstructed 1965, Kröller-Müller Museum Sculpture Garden, Otterlo, the Netherlands

↓ Figure 7: Rendering by Herzog & de Meuron of initial proposal (2005–2008) for the Parrish Art Museum, Southampton, New York. A subsequent design, also by Herzog & de Meuron, will be inaugurated in late 2012

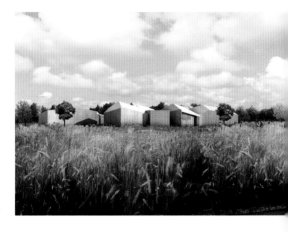

began putting these ideas of institutional informality, incrementality, and openness into practice.

In the Netherlands, the Kröller-Müller occupies a park close to the St. Hubertus hunting lodge, completed in 1920 by the architect H. P. Berlage for the museum's original patrons, Anton and Helene Kröller-Müller (the family's wealth came from shipping and mining). The main museum building (1938) is by Henry van de Velde and was extended in the 1970s by Wim Quist, a Dutch Modernist. There are two sculpture pavilions: Gerrit Rietveld's, first erected in Arnhem in 1955, was re-built here in 1965 (figure 6); Aldo van Eyck's was reconstructed in 2006. In the late 1990s, this heritage of pavilions was extended with three gatehouses—in brick, timber, and metal, respectively—designed by the vanguard Rotterdam practice MVRDV.

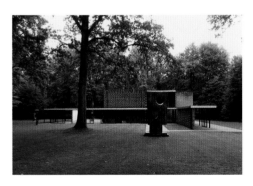

For a spectacular site in China's Sichuan Province, a group of young architects proposed, shortly before the tragic 2008 earthquake, a set of small museums, each dedicated to the work of one Chinese artist. The Beijing-based architect Pei Zhu envisioned an ovoid pavilion for painter Yue Minjun. Pei describes his design as being inspired by both the famous white cube of galleries worldwide and the smooth pebbles found in the adjacent Shimeng River. It's a rather beautiful object. Yet one wonders at the collectivity of these pavilions—this museum of museums—each one speaking a distinct architectural language.

Certainly this sense of menagerie is apparent at the most famous of contemporary art venues, the Giardini Pubblici in Venice, where almost thirty countries have, over the course of the twentieth century, erected pavilions in a riot of styles. Few seem particularly conscious of their neighbors. One glorious exception is the Nordic Pavilion (1962) designed by Sverre Fehn as a porous roof of deep beams that permit the penetration of preexisting trees. These often hermetic pavilions of the Giardini inevitably have an effect on the art exhibited in Venice every two years.

In London's Hyde Park, the now-annual Serpentine Pavilion is something of a *cause célèbre* for the art world. However, unlike the buildings contributing to today's more extensive institutions, the Serpentine Pavilion is normally a single work in verdant isolation. The appeal of pavilions and follies is of course millennia-old and found across cultures from England, with its faux natural parks, to imperial Japan.

In the hills close to Rome, ideas of architecture as a collection of parts are still evident at the extensive complex of ruined pavilions, in truth a multi-part palace, erected by the emperor Hadrian near Tivoli. If Japanese and Scandinavian models exhibit sobriety and stylistic unity, Hadrian's vision two millennia ago was exuberantly eclectic with allusions to distant and even hypothetical places.

This vision of a multivocal landscape of pavilions had great appeal to Postmodernists in the 1960s and '70s. In *Perspecta 6*, that wily observer Charles Moore marveled also at the plasticity of the constituent parts of the villa. He wrote of the "excitement in the masonry forms themselves, in walls and vaults and especially in domes, and in spaces that must once have been domed." Hadrian's Villa could for Moore be a model for multiple spatial experiences. Furthermore, these forms are resilient. "It is not the sort of place which

insists, for its beauty, that nothing could be added or nothing taken away."[3]

In recent years, Herzog & de Meuron approached their initial proposal for the Parrish Art Museum also as a conglomeration of pavilions—structures growing, in an almost organic way, across the flat maritime ground of Southampton, Long Island (figure 7). Key constituent pavilions were designed to represent the volume and lighting conditions of studios, often repurposed barns, used by influential artists including Willem de Kooning and Roy Lichtenstein who once frequented the area.

These mnemonic elements acted as anchors or nodes to a host of auxiliary buildings of similar size, shape, and texture tethered one to the next in informal fashion. This proposal, since redesigned in more compact form, was therefore for a set of pavilions (solids) with eccentric interstitial spaces (voids). As at Louisiana, the pavilions had a common or uniform language that, in Southampton, would recall both vernacular building traditions and the artistic legacy of Long Island's East End.

Pavilion museums ideally allow nature and the seasons to be experienced together with art. They may be most successful when architects work concertedly in tandem, alert to the possibilities of interstitial space, with a collegial eye for those external courts and pathways comparable

15

↓ Figure 8: Exterior rendering of the Cafesjian
Center for the Arts by David Hotson Architect,
Yerevan, Armenia, showing elevated terrace with
view toward Mount Ararat

↓ Figure 9: Interior of PACCAR Pavilion by Weiss/
Manfredi, 2006, Olympic Sculpture Park, Seattle,
showing installation by Pedro Reyes, 2007

Figure 10: View of Khmer bronze heads in the
Hohe Galerie by Erwin Heerich, 1983, Insel
Hombroich, Germany

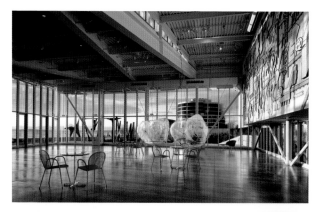

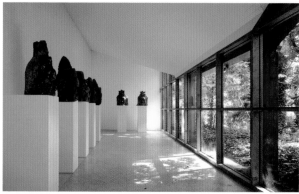

to a labyrinth. After all, in a labyrinth one might experience the thrill of encounter. Today's institutions therefore tend to reject the monolithic in favor of multiplicity, freedom of circulation, and collective sensibility.

FROM BROWNFIELD TO GREEN MAZE

The brownfield or postindustrial site remains a potent locus for new museums and the accommodation of art. With economic downturn, such reutilization of found assets seems especially attractive and apt. Indeed many museums that nowadays appear to have parklike settings—including Seattle and Hombroich—have had to undergo intensive environmental rehabilitation.

In Russia, patrons such as Daria Zhukova and her Iris Foundation are also drawn to postindustrial fabric. Garage Center for Contemporary Art is named for its home, the Bakhmetevsky Bus Garage, a vast parallelogram designed as a Soviet marvel by Konstantin Melnikov. Garage now anticipates a move to Gorky Park, an evolution from brownfield to green maze. Star architect Rem Koolhaas plans to first rehabilitate

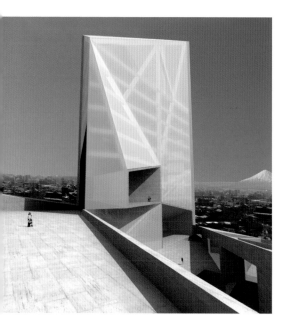

a decaying 1960s restaurant, then appropriate an adjacent hexagonal pavilion built in the 1920s. This new manifestation of Garage sees the institution visibly engage with the public realm of this popular park.

South from Moscow, in Armenia's capital, Yerevan, a monumental flight of stairs has been reinterpreted by New York architect David Hotson as the Cafesjian Center for the Arts. This is more than simple refurbishment of a postindustrial site— it re-presents a kind of infrastructural folly fecund with symbolism. Escalators ascend inside the hillside where Hotson proposes to install giant stills from classic Armenian films, stretching the images to anamorphic principles so that they shift into focus as visitors ascend through the interior. High above, new crystalline pavilions frame dramatic distant views to Mount Ararat, the national symbol (figure 8). This is a landscape project but a landscape of hard surfaces.

In Seattle, the Olympic Sculpture Park is also about revitalization, connectivity, and viewing, a new synthesis of topography, nature, and the city. The park, a project of the Seattle Art Museum, has as much to do with civic leisure as any didactic imposition of art. Its development first entailed a massive clean-up operation on the site, previously used for fuel storage. The architects Marion Weiss and Michael Manfredi stretched a zigzag of pathways and gardens across a major traffic artery and train tracks, to connect the urban core to the shore of Puget Sound. The design of retaining walls, in collaboration with engineers Magnusson Klemencic Associates, articulates this sense of stretching, maximizing the pedestrian experience.

In fact, Seattleites are already familiar with inventive infrastructural design. In the 1970s, Bay Area landscape architect Lawrence Halprin spanned Interstate 5 with Freeway Park, a remarkable hybrid of bridge, cubic pools, and planting boxes.

The Olympic Sculpture Park performs similar infrastructural tasks yet is also a knowing re-presentation of the region. Triangular tranches of park between the zigzagging path are designated as "the Valley, an archetypal forested landscape of the northwest; the Grove, a deciduous forest of quaking aspens and plants adaptable to the city; and the Shore, a waterfront habitat for fish and wildlife."[4]

As one might expect in a region also known for technological invention, the park is wired to facilitate future art projects. The PACCAR Pavilion—PACCAR is a truck company from nearby Bellevue— accommodates installations such as, in 2007–2008, Pedro Reyes's *Capula XVI and XVII* and *Evolving City Wall Mural* (figure 9). Ideally, the Olympic Sculpture Park can host further temporary works, perhaps even small structures like the greenhouse shaped by artist Mark Dion almost as a miniaturization of the PACCAR Pavilion.

In Germany, the Raketenstation is the second phase of a utopian undertaking that began with the creation of Insel Hombroich (figure 10) by businessman Karl-Heinrich Müller. Next to a tributary of the Rhine, the gardens of Rosa Haus and surrounding farmland were allowed to return to a bucolic and almost primeval state. Today the place has a surprisingly natural atmosphere in this area not far from mines, autobahns, and large cities. This is due in large part to the work of landscape architect Bernhard Korte, who has noted of Insel Hombroich that "dominating nature by cutting, hoeing, breaking and affecting aesthetic piety are no longer necessarily essential."[5]

The Raketenstation could never be mistaken for nature. This extensive site is physically close to Insel Hombroich yet has an entirely different character. The former NATO base is a rather bleak and exposed world of berms, tarmac, and missile sheds surviving from the Cold War. The landscape strategy here is a case of retaining much of the site's recent history, converting military sheds for communal activities and as artist studios. The severe terrain is however punctuated by sculptural buildings by three contemporary masters: Tadao Ando, Álvaro Siza Vieira, and the late Raimund Abraham.

In his native Japan, Ando has played a major role in the redevelopment of Naoshima, the first of several islands benefitting from the patronage of Benesse Holdings. On Naoshima, Ando has realized a half-dozen buildings that exhibit his characteristic use of concrete and robust form to frame views of sea and sky. Visitors may be unaware of the local industrial legacy, although this is evident in the Mitsubishi Materials plant at Naoshima's north end. In response, Ando took a lead in the reforestation of the island.

The architect's commitment to reforestation and sustainability has now extended to an ongoing initiative, *Umi-no-Mori*, to plant a half-million trees on a landfill island in Tokyo Bay.

On Inujima, a smaller island northeast of Naoshima, the architect Hiroshi Sambuichi has reworked a former copper refinery in an impressively environmental way. His redesign ventilates a labyrinthine underground passage that visitors navigate before encountering a vaulted hall with a suspended artwork by Yukinori Yanagi. Yanagi has also collaborated with the architect Kazuyo Sejima on three small "houses" dispersed through Inujima village. On a third island, Teshima, Ryue Nishizawa and Rei Naito have built a billowing concrete structure inspired by a drop of water.

Sustainability on these islands is not simply a scientific matter. Many unorthodox sites are appropriated for art. On Naoshima, framed photographs by Hiroshi Sugimoto are placed as if by magic in the natural terrain (figure 11). Some houses and sites in Honmura village are used for interventions such as *Minamidera*, a collaboration between Ando and James Turrell.

In this resuscitation of village life, a rapport is established between locals and visitors as the latter are invited to wander and explore. They may even discover, on Teshima, the white, lingam-like glass sculpture sited by Mariko Mori in the middle of a remote pond.

GARDENS OF TOIL AND PLEASURE

Elsewhere on Teshima, a swooping canopy of shingles by the architect Ryo Abe encircles an outdoor restaurant (figure 12). By the harbor, the artist Tobias Rehberger has remodeled a generic house to create a vibrantly patterned café. Such radical moves contribute to broad communal benefit. Many of these sites include studios, to allow art or applied art to incubate, and residential spaces. This strategy of inclusion helps keep the institutions

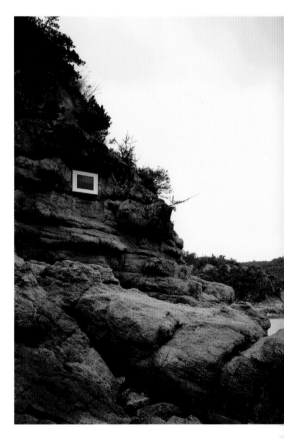

active, promises surprise, and is especially relevant in remote locations.

For several years, the German artist and theater designer Christoph Schlingensief had the extraordinary idea to establish an opera house in Africa. He settled on Burkino Faso and the German-trained, Burkinabé architect Diébédo Francis Kéré. Schlingensief died prematurely in 2010, yet the Operndorf Afrika is today under construction thirty kilometers from Ouagadougou. Critical for the success of the village plan are the radiating bands of pavilions—for art, technical services, and guest accommodation—that surround and ideally sustain the opera house.

In the case of Hombroich, a few fortunate artists already live and work *in situ* (Anatol Herzfeld and Gotthard Graubner at Insel Hombroich; Oliver Kruse at the Raketenstation; Katsuhito Nishikawa at both). As

↓ Figure 12: View of Shima Kitchen by Architects
Atelier Ryo Abe, 2010, Teshima, Japan

Figure 13: Pavilion in Jinhua Architecture Park by
Tatiana Bilbao, 2002, located along Yiwu River in
Jinhua, Zhejiang Province, China

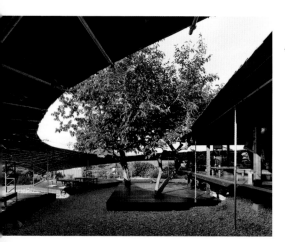

Hombroich contemplates a third phase of
development, more than a dozen architects
and artists are collaborating on a master
plan, the spaceplacelab, for innovative
work/live scenarios on sites contiguous to
the Raketenstation. Might art and nature
yet provide a model for sustainable living?

In the hills south of Rome, the Depart
Foundation's Grand Traiano Art Complex
intends to not only exhibit art but be a gen-
erator of ideas and facilitate new cultural
businesses; hence, the residential studios
proposed by Swiss practice HHF architects
within a master plan by Los Angeles archi-
tects Sharon Johnston and Mark Lee and
landscape design by Topotek 1.

The site is in essence the walled garden of a
villa. Within this fixed perimeter, Johnston
Marklee proposes mixing new pavilions
that rotate and stack the proverbial white
cubes of Modernism with rehabilitated
"found" structures. There's an aesthetic
frisson in the conjunction of old and new.
Moreover, the communal spaces between
the built forms are as powerful, as charged,
as the forms themselves.

There's a sense of typological play reminis-
cent of larger, more urban plans—a distant
echo perhaps of that villa nearby in Tivoli.
This nascent urbanism recalls the comment
by Colin Rowe, co-author of *Collage City*,
that "the garden may be regarded as both
a model of the city and as a critique of the
city."[6] It is indicative of a new mood that
both Johnston Marklee and HHF have
developed in part through collaboration,
both with artists and with other young
architects, often adding constituent ele-
ments—pavilions of one sort or another—
to some greater master plan.

For example, in Lausanne, close to Lake
Geneva, Johnston Marklee is working
side-by-side with nine architectural teams
on a housing development planned by
the emerging Basel practice Christ &
Gantenbein. On the other side of the
world, Johnston Marklee is one of ten
practices designing pavilions for culture
and shelter along the Pacific coast of
Chile's Concepción Province. And in
Mexico, HHF has already built a swirling
pavilion in concrete as one of several
interventions along a historic pilgrimage
route in the state of Jalisco.

HHF's colleagues in Jalisco include Chinese
artist Ai Weiwei and Mexican architect
Tatiana Bilbao. Weiwei may have instigated
the current crop of collegiate landscape
projects with the linear park along a river-
bank in Jinhua, his ancestral city south of
Shanghai. For Jinhua, Weiwei and Tate
Modern architects Herzog & de Meuron
(together they designed the Beijing Olym-
pic Stadium) selected sixteen designers,
Chinese and non-Chinese, to design one
structure each. The selected architects
included HHF, Christ & Gantenbein, and
Tatiana Bilbao (figure 13).

North of Jalisco, Bilbao is collaborating
with landscape architects TOA (Taller
de Operaciones Ambientales) to revive
the Jardín Botánico de Culiacán, almost a
brownfield, and incorporate works by lead-
ing Mexican and international artists. Like
the architectural interventions, the art is
distributed around the park and ranges in
imprint from video and conceptual pieces
to structures as large as buildings. Many
of the artists drew inspiration from the
botanical context.

Bilbao's contributions are pavilions typi-
cally gathered like boulders in groups,
their exposed concrete walls capturing
the mobile shadows of foliage above. As
this is a functioning botanical garden, one
range of low-rise construction—a multi-
part pragmatic pavilion—will accommo-
date storage and maintenance needs. TOA
is responsible for the restoration and ame-
lioration of the botanical collection as well
as ensuring a more sustainable water cycle
in the desert climate.

This green maze, with pathways and water
channels zigzagging through the under-
growth, is very much a civic space. Over
three centuries ago, the English poet
Andrew Marvell, commenting on the spe-
cial appeal of gardens, wrote, "Society is all
but rude, To this delicious Solitude."[7] As at
the other new institutions blending art and
landscape, visitors can willingly lose them-
selves in Culiacán. Nevertheless, it is also a
new form of public space, as witnessed by
the many *quinceañeras*, girls in ball gowns
celebrating their fifteenth birthdays.

Like Culiacán, Instituto Inhotim empha-
sizes its collection of plant specimens and
its ecological direction as well as its art.
Adjacent to some of the many mines across
Minas Gerais state, Inhotim began as a
farmstead before Bernardo Paz instigated
successive modifications inspired by

Roberto Burle Marx, the seminal Brazilian landscape architect. Burle Marx returned home from Europe in 1930 infused with Modernist aesthetics yet determined to examine indigenous Brazilian plants. At Inhotim, in old age, he made suggestions rather than a formal plan; but one senses his painterly hand in the many curves and in the palette of trees, flowers, and undergrowth.

That attention to botany and to the environment continues to inform Inhotim. The visitor is encouraged to explore various pavilions—white cubes—set near the serpentine ponds and to venture out to singular installations by artists on the fringes of the park. As at other new institutions around the world, artists are often inspired by local nature and customs; Adriana Varejão, for example, incorporated images of local birds and hallucinogens in the tilework at her pavilion. Among many buildings by Arquitetos Associados, the extensive new education pavilion is named for Burle Marx and embodies progressive cultural intent.

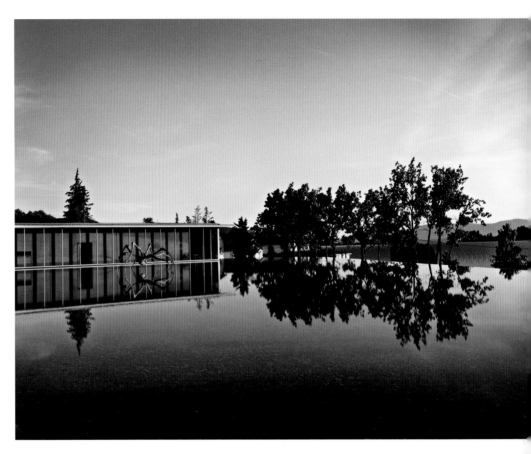

The vineyard is a very different type of garden. Not by chance, several vineyard owners—in California, Australia, Argentina—are also art collectors. Château La Coste in the South of France is the most interesting of these art vineyards, with a pavilion by Tadao Ando and a vaulted wine-making facility by Ateliers Jean Nouvel (figure 14). Johnston Marklee is also working amid vines, extending a winery in Montepulciano for their Grottaferrata clients. The site will furthermore accommodate artists-in-residence and be home to a major installation by Daniel Buren. Thus toil and the pleasures of nature will be joined in architecture.

At these sites in radically different contexts around the world, architects and artists, curators and museum directors both depart from the white cube and knowingly return to its many attributes.

The white cube has been pavilionized, liberated into fragments that allow for more unorthodox interior spaces and more complex exterior relationships. This new landscape, the green maze, addresses local realities, the importance of ecology, and the passing of time. It suggests that culture is always in evolution and that promenade is a route to multiple options for contemporary art and its display.

1 John Russell, "Art View: In London, a Fine Home for a Major Collection," *New York Times*, February 10, 1985.

2 Knud Jensen, quoted in Lawrence Weschler, "Louisiana in Denmark," *New Yorker*, August 30, 1982.

3 Charles Moore, "Hadrian's Villa," *Perspecta: The Yale Architectural Journal* 6 (1960): 18.

4 Marion Weiss and Michael Manfredi, "Architects' Statement," in *Olympic Sculpture Park* (Seattle, WA: Seattle Art Museum, 2007), 16.

5 Bernhard Korte, "Museumspark Insel Hombroich," *Garten + Landschaft* 1 (1988): 34.

6 Colin Rowe, "The Present Urban Predicament," *Cornell Journal of Architecture* 1 (1981): 16–33.

7 Andrew Marvell, *The Garden*, c. 1680.

Sculpture's Nature

Marc Treib

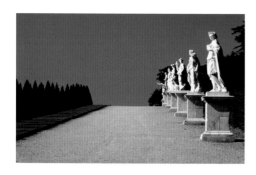

There may once have been a time when art, architecture, and landscape were conceived as a single entity, or at least functioned symbiotically. The *grand siècle* French estate of Vaux le Vicomte, for example, assembled the talents of the artist Charles Le Brun, the architect Louis Le Vau, and the landscape architect André Le Nôtre in addition to a host of lesser known painters and sculptors (figure 1). Le Corbusier shared that dream of the synthesis of the arts, most notably realized in his building design and electronic spectacle for the Philips Pavilion at the 1958 Brussels world's fair, there collaborating with the composers Edgard Varèse and Iannis Xenakis.[1] These were somewhat rare moments, however, even if we include historical imperial precincts such as those in Japan, China, and India. More characteristic of our own time has been an independence of the plastic and design arts, each pursing its own, often Modernist, path. In the process, in relation to architecture sculpture often was reduced almost to a symbol, a marker, a sign of completion and good taste—and, at times, the last vestige of non-orthogonal form and color. Less commonly has there been the mutually enriching dialogue between building and sculpture that is the aspiration of the projects explored here.

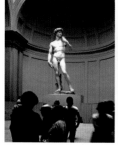 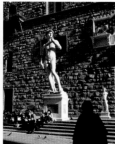

Sculpture within a museum enjoys a managed setting and a controlled manner by which the work will be approached and scrutinized. Sculpture outdoors experiences far different conditions. Changing rather than constant light vivifies form, surface, and readings. Areas shaded by morning may become painfully reflective by afternoon; color shifts accompany the elevation and fall of the sun (figures 2–3). Rain animates surfaces; vandalism hampers longevity. Heterogeneous surroundings can diminish—or at times enhance—the effect of the work, which, freed from the physical limits of the gallery may assume a scale approaching the colossal.

No individual work exists without some immediate context, an object or frame or support against which it is perceived, considered, and interpreted. Particularly in the modern era, when the demise of the picture frame to some degree effaced the distinction between figure and ground, the spatial matrix for sculpture has come to play a more consequential role in defining the artwork.[2] In the Minimal art of the 1960s, for example, the reciprocal relationships of object, space, and perceiver achieved prominence—whether the perceiver embraced his or her heightened role or condemned that interaction as theatrical.[3] Sculpture, space, and setting—like the figure and ground of two-dimensional works—are inextricably wed.

In actuality there have been rather few models for the display of sculpture outdoors beyond the single work positioned in the garden, on the street, or affixed to a building. First is the *sculpture park*, to some degree based on the eighteenth-century English landscape garden, but substituting monumental sculptures for the follies that once served as the "eye catchers" to those following the suggested circuit (figures 4–5).[4] But in today's

↑ Figure 1: Gardens at Versailles, designed by André Le Nôtre, late seventeenth century

Figures 2–3: Michelangelo Buonarroti, *David*, 1504, at the Accademia, Florence, and the Piazza della Signoria, Florence

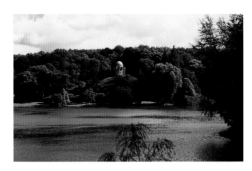

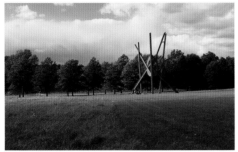

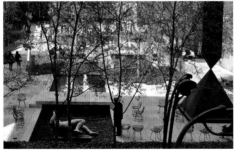

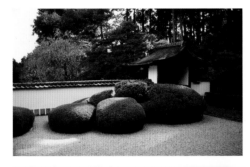

↑ Figures 4–5: The gardens at Stourhead, England, designed by Henry Hoare II, begun c. 1740s; View of sculpture by Mark di Suvero at Storm King Art Center, designed by William Rutherford, c. 1972, Cornwall, New York

Figures 6–7: Shoden-ji, seventeenth century, Kyoto, Japan; Museum of Modern Art sculpture garden, designed by Philip Johnson and James Fanning, 1951, New York City

sculpture park, the respective roles of landscape and object have been reversed: now the landscape—at least in theory—creates a vegetal and spatial frame that reveals the sculpture to best advantage. Obviously sculptures of grand scale are more easily sited than more intimate works that normally end up closer to the museum building.[5] Several of the sites discussed here depart from any strict application of this model, however, encouraging the visitor to wander with no prescribed sequence. Insel Hombroich, for example—whose brick pavilions themselves function as sculptural objects—unfolds in a seemingly random arrangement. While the paths connecting the buildings suggest a route, nothing is lost by moving in alternate ways. Other projects evidence a tighter integration among sculpture, the landscape itself, and the vegetal dimension. The Jardín Botánico de Culiacán, as the name tells us, situates art within a landscape created with a purpose equal to the sculpture garden; in certain instances today arbors, pergolas, and even gardens as a totality are regarded as art because they have been designed by artists rather than landscape architects. Roberto Burle Marx's participation in the planning of the Instituto Inhotim, on the other hand, underscores the role that landscape design plays in conceiving sites for groups of sculpture.

The expanded acreage enfolding the Benesse buildings on Naoshima illustrate that at an extreme, art park, landscape, and townscape can be regarded as a single entity. Tadao Ando's numerous buildings on the island complement several traditional houses converted to artworks while individual pavilions and sculptures instigate a rereading of what has been in the past domestic or productive terrain.

The second category, *courtyard*, is particularly common to urban museums where land holdings are constrained. The challenge here is to maximize the space within the walls, convoluting the paths of circulation and vision to accommodate more works while diminishing the impact of the site's external boundaries.[6] If there is a historical model, it might be more the Chinese than the English garden, although in its purer moments the simplicity of Japanese dry gardens could be taken as a precedent (figure 6). A select few sculptures are allowed sufficient breathing room, perceived in visual isolation, but still sensed as a family. The Museum of Modern Art's sculpture garden is the classic example of the type (figure 7). Articulated by stands of trees, a water course, and stepped floor levels, the space of the courtyard reads more complexly than its plan would suggest.[7] These spaces bear the closest parallels with indoor gallery display: art within an architectonic space. Rather than the separation of works inherent in the sculpture park, sculptures within the court tend to be viewed in groups, although the focus commonly falls on the work immediately before the eye. This is potentially a powerful opportunity, but the density of sculptures hampers the achieving of independence for any given work. New sites tend to abandon this model, either due to the larger land area available or from a different attitude toward creation and display. In this light we could read the Grand Traiano Art Complex as an expansion of the traditional court, yet many of its precepts—for example, the confounding of single readings and movement—are expanded to a level more characteristic of the park than the court.

The *vegetal room*(s) comprises the third category, with the Italian Renaissance garden as a model.[8] Open-air rooms enclosed by hedges and walls correspond to the roofed galleries within the museum; there is order and decorum, with sculpture installed in consideration of the green rooms rather than vice versa (figures 8–9). In many instances, the siting is effective and good; in others, works may suffer from this quasi-pastoralism. Although exceptions certainly exist, in general the *sculpture park* tends to be *centrifugal* and outward looking, while the *court* and the *vegetal room* tend toward the *centripetal* and internalized, circulating people and views within a bounded frame.

The rise of site-specific sculpture has nurtured the development of the fourth category, one that integrates sculpture and landscape, and one we might term *sculpture with landscape*, that is, the two working together.[9] Here the artist is commissioned to create a new

21

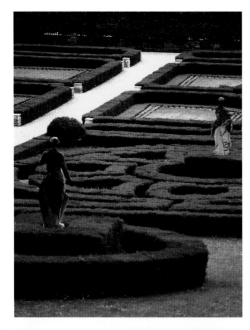

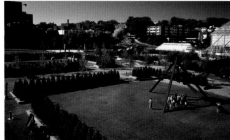

work for some situation within the grounds; often the place, the materials, and the forms are decided through the mutual consent of curator and creator with budget or schedule serving as the primary constraint. Creativity, then, takes form as the adjustment or reconfiguration of the conditions or materials *in situ*, and it is this recasting that asks the visitor to consider the work as art (figure 10).[10] This brings us to a last consideration, the *site as sculpture*. Here we enter a new territory, not a landscape in which sculpture is displayed, but a landscape to be taken as sculpture in and of itself—in some cases also supporting the duties normally assigned to a designed landscape. Unlike land art, which often focuses on form rather than space, works like Isamu Noguchi's *California Scenario* use sculptural objects to articulate a space already bounded by buildings (figure 11). Solid and void are together taken as a single sculpture.

A discussion of *earth art*, or *land art*, or *earthworks* lies beyond the limits of this brief commentary. Whether an attempt to escape consumerism or the dimensional confines of the gallery, whether to engage the broad landscape or simply to use the stuff of the desert, these works thoroughly conflated landscape and sculpture.[11] Robert Smithson's 1970 *Spiral Jetty* is perhaps the best known of the genre (see Ryan, figure 1). Michael Heizer's *Double Negative* of 1969–1970 was a more consequential act of transformation, playing the straight line of the bulldozer cut against the irregular edge of the mesa, and created space by carving into the earthen surface. And with a lighter and more elegant touch, the stainless steel javelins of Walter De Maria's 1977 *Lightning Field*, located in New Mexico near Quemado, dances with the topography with an arrangement based on American and European measures. These were works far removed from the big-city museum, and to experience them firsthand demanded significant travel. The Naoshima and Inhotim sites, like much land art, require time and money; the artwork becomes a grail and the process a pilgrimage to a landscape only a fraction of which will be designed and controlled.

If the type of setting is one major factor, its correlative is the nature of the sculpture itself. In *Being and Circumstance: Notes toward a Conditional Art*, published in 1984, the artist Robert Irwin established four terms by which sculpture could be categorized.[12] The first, *site dominant*, comprises studio works created with limited conscious regard for their ultimate display space—they are created independently and then positioned. *Site adjusted*, on the other hand, addresses the specifics of, say, a commission, but still remains a signature work. Here a Henry Moore commissioned for a particular location could serve as an example. A stronger engagement with the characteristics of the site qualified Irwin's third category, *site specific*, although the materials and the formal vocabulary of the piece still assured that the maker of the work would be recognizable. Irwin uses Richard Serra as an example. Irwin's last category, *site conditioned/determined*, proposes sculpture that derives completely from the specifics of the site, and that the idea, materials, and configurations come—and can only come—in response to that particular place, at that time, under those conditions.[13] These ideas and their implications bear strongly on the creation of the space for sculpture—or sculpture for spaces—with specific repercussions in outdoor spaces designed to exhibit sculpture in relief or in the round.

Any outdoor space—court or garden—admits far more variables than the static light levels and climatic management of the white cube that has long been the norm for modern gallery design. In the outdoors, change occurs daily, annually, and chronologically. The first two of these trajectories are cyclical, the third is linear. The diurnal cycle of day and night witnesses changes in light intensity, direction, and quality. Seasons affect the properties and quantity of light as well as the advance or retreat of vegetation that may subtly or radically affect the place of display. Over the years, other dimensions enter into consideration: the growth of the vegetation, the aging of the work itself, perhaps even the increase or decline in the number of viewers.

The independent sculpture, unless squarely executed as site-specific, stands somewhat detached and homeless, and we have all witnessed situations in which a work looked par-

↑ Figure 8: Giardino dei Giusti, begun late fifteenth century, Verona, Italy

Figure 9: Sculpture Garden, designed by Edward Larrabee Barnes and Peter Rothschild, 1988, Walker Art Center, Minneapolis, Minnesota

ticularly poor and diminished through no fault of the artist. If we accept that the situation truly affects the presence and interpretation of the work, we need also acknowledge that the space in which a work is displayed at least in part defines it. In that sense, unless the sculptor fully controls the placement of the work—as well as its formation—one can say that the patron or curator or spatial designer shares in creating the sculpture, or at the very least, influences its reception. Thus the design of sculpture gardens or sculpture courts is by no means mute and non-invasive.

Lastly, one must note the plethora of buildings and landscapes that today ask to be read as artworks in and of themselves. The wild entrance spaces of the Akron Museum of Art by Coop Himmelblau, virtually any building by Zaha Hadid, and of course Frank Gehry's Guggenheim Museum in Bilbao all raise the question of the line between architecture and sculpture. A similar dilemma touches the twisted landforms, alignments with the summer solstice, or shaped vegetation that have become part and parcel of many contemporary landscapes. Is Alvar Aalto's light-processing church in Vuoksenniska any less an artwork than a *Skyspace* by James Turrell? Are earth forms by Hargreaves Associates less artworks than excavations by Michael Heizer? Interestingly, in Bilbao, outdoor sculpture is famously represented by Jeff Koon's *Puppy*, an endearing piece that reintroduces figuration—however abstractly—and an injection of nature—however miniature—into an urban setting. Just what is nature or landscape, and what is sculpture, is left somewhat in the air. Or perhaps, better stated: on the ground. Here the garden may also serve as land art, fusing aesthetic and spatial concerns. And even landscapes planted more for social than aesthetic reasons possess a sculptural dimension and produce a formal pleasure nonetheless.

1 Although working as an architect for Le Corbusier at the time, Xenakis had already begun work in musical composition. He composed the two-minute interlude *Concrète P-H*, which played during the audience's entrance and exit. See Marc Treib, *Space Calculated in Seconds: The Philips Pavilion, Le Corbusier, Edgard Varèse* (Princeton, NJ: Princeton University Press, 1996).

2 Robert Irwin, *Being and Circumstance: Notes toward a Conditional Art* (Larkspur: Lapis Press, 1984).

3 Michael Fried, "Art and Objecthood," *Artforum*, June 1967.

4 One of the best examples of this type is Storm King, north of New York City; see John Beardsley, *A Landscape for Modern Sculpture: Storm King Art Center* (New York: Abbeville: 1985). For general reading on the English landscape garden, see Edward Hyams, *The English Garden* (New York: Harry Abrams, 1966); Laurence Fleming and Alan Gore, *The English Garden* (London: Michael Joseph, 1979); and Timothy Mowl, *Gentlemen & Players: Gardeners of the English Landscape* (Thrup, UK: Sutton, 2000).

5 One notable exception is the Franklin Murphy Sculpture Garden at UCLA, where virtually all the works on display are a size nearly that of the human body. See Cynthia Burlingham, ed., *The Franklin D. Murphy Sculpture Garden at UCLA* (Los Angeles: Hammer Museum, 2007).

6 See Marc Treib, "A Sculpture for Sculpture," in *Isamu Noguchi: A Sculpture for Sculpture, The Lillie and Hugh Roy Cullen Sculpture Garden*, ed. Alison de Lima Greene (Houston, TX: Museum of Fine Arts, Houston, 2006).

7 The sculpture garden was designed by Philip Johnson with James Fanning in 1953; it has been modified several times, including a reconstruction as part of the most recent museum expansion. For a complete history of the garden, see Mirka Benes, "A Modern Classic: The Abbey

Aldrich Rockefeller Sculpture Garden," in *Philip Johnson and the Museum of Modern Art*, Studies in Modern Art 6, ed. Barbara Ross (New York: Museum of Modern Art, 1998).

8 A relatively recent example of the type is the Minneapolis Sculpture Garden at the Walker Art Center. See Martin Friedman and Marc Treib, "Minneapolis Sculpture Garden," *Design Quarterly* 141 (1988).

9 One could argue that in most instances this type represents more of an evolution of the sculpture park than a truly new landscape.

10 In venues like the Grizedale Reserve in Cumbria, England, artists originally produced works using only the materials found in the forest; they could cut no living things nor import alien materials into the preserve.

11 For an overview on land art, see Alan Sonfist, ed. *Art in the Land: A Critical Anthology of Environmental Art* (New York: E. P. Dutton, 1983); John Beardsley, *Earthworks and Beyond* (New York: Abbeville, 1984); Jeffrey Kastner and Brian Wallis, *Land and Environmental Art* (London: Phaidon, 1998); and Suzaan Boettger, *Earthworks: Art and the Landscape of the Sixties* (Berkeley: University of California Press, 2002).

12 Irwin, *Being and Circumstance*.

13 To some degree, Irwin's own work has slid across the last two categories; his disk paintings of the 1970s, for example, sought to erase the distance between the sculptural piece and its support, as a means to unify sculpture, wall, and space. Irwin framed the quest in this way: "How do I paint a painting that does not begin and end at the edge but rather starts to take in and become involved with the space or environment around it?"

↑ Figure 10: Richard Serra, *Te Tuhirangi Contour*, 2001, The Farm, Kaipara, New Zealand

Figure 11: Isamu Noguchi, *California Scenario*, 1982, Costa Mesa, California

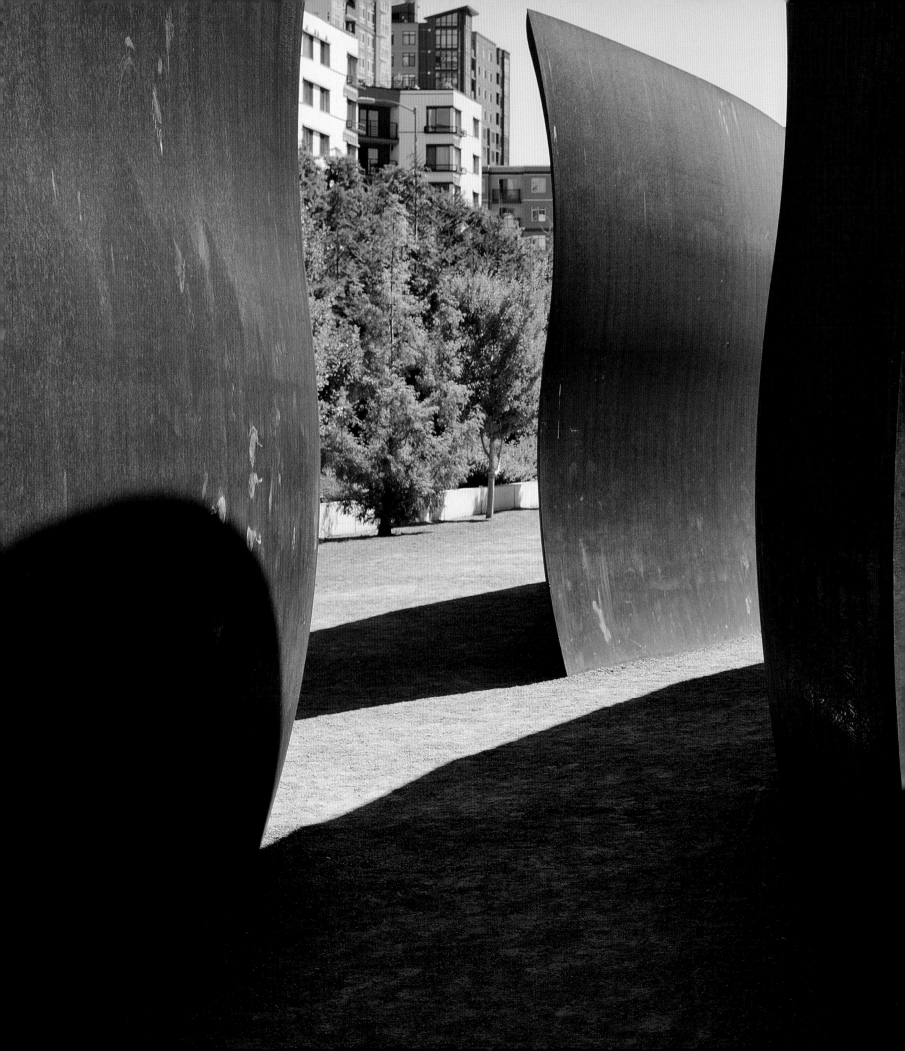

The Olympic Sculpture Park connects the urban grain of Seattle with the natural splendor of Puget Sound and the Olympic Mountains beyond. This revitalization of a former Unocal fuel yard overlooking the water necessitated an intensive environmental cleanup and the removal of over 120,000 tons of contaminated soil before construction could begin. Inaugurated in 2006, the Olympic Sculpture Park also represents a strategic move by its parent institution, the Seattle Art Museum (SAM), away from the museum's primary home and into the public realm.

Former SAM Deputy Director of Art Lisa Corrin has written that "the museum revisited its mission and embarked on the creation of a fresh model of how the museum would operate in the city, less through a single architectural entity with a monolithic presence than by dispersing its identity and its vision—to connect art to life—throughout Seattle."[1]

New York–based architects Weiss/Manfredi won the Olympic Sculpture Park commission through competition. The practice's work is characterized by close attention to ground surface, both natural and artificial, and by the integration of buildings into more extensive landscape ideas, as seen in their Women's Memorial at Arlington National Cemetery and the Museum of the Earth in Upstate New York.

In Seattle, Weiss/Manfredi faced daunting challenges due to the site's steep slope and the presence of both a four-lane roadway and functioning train tracks. These existing features presented three distinct, parallel contexts—the urban street, a kind of interstitial no-man's land, and a fragment of seashore. The winning design extends across the road and rail arteries to connect the city to the seafront below, transforming the site into a single park. The Olympic Sculpture Park is thus a response to its urban, postindustrial context and, as with Millennium Park in Chicago, allows the city to be seen and enjoyed in new ways. Both are venues for progressive art and everyday leisure.

In response to the difficult terrain, Weiss/Manfredi created a zigzag path that descends from a taut, elongated building—the PACCAR Pavilion—to the shore. To reach the water, visitors follow a 2,200-foot route that links landscapes characteristic of the Pacific Northwest. They experience a forested valley that is typical of the region, a deciduous grove with plants that are adaptable to the city, grass and wildflower meadows, and the shoreline that has been shaped by wind and saltwater. Charles Anderson, who acted as consultant landscape architect for the project, is known for his ecological intelligence and preference for indigenous planting.

Moving through these various landscapes, the visitor is presented with views that contrast the docks, city, mountains, and sea. As Weiss/Manfredi state: "Our ambition was to create connections where separation existed, illuminating the immeasurable power of an invented setting to bring together art, city, and water—implicitly questioning where the park begins and where the art ends."[2]

Visitors can enter the park in several ways. An ideal starting point is the PACCAR Pavilion on Western Avenue. This attenuated glass-and-metal building is used for visitor facilities (information desk, bathrooms, café, offices) as well as temporary art installations. These installations are critical for the institution to remain fresh and

attractive to visitors. For the inauguration, the young Mexican artist Pedro Reyes had two works on view: *Evolving City Wall Mural* (2006) and *Capula XVI and XVII* (2007) (see Ryan, figure 9).

The PACCAR Pavilion's stainless steel elevation to Western Avenue captures light in beguiling ways, while the roof cantilevers out to the northwest to gesture toward a gently stepped outdoor auditorium. The building also sits atop an elegantly detailed parking garage: for Weiss/Manfredi, infrastructure is as worthy of design attention as formal museum space. Here their language of folded and tailored planes is particularly adept at integrating the flow of pedestrian and vehicular traffic.

From the pavilion, visitors are encouraged to meander and explore the park and to encounter sculpture from the SAM collection. The retaining walls that follow the zigzag path are made from large panels of concrete that stagger in plan and tilt in section, bringing a sense of scale and rhythm to this basic infrastructural element.

The outdoor terrace descends to Richard Serra's *Wake* (2004), a remarkable array of five toroid forms made of weathered steel. In the middle of the park, a large red stabile by Alexander Calder, *Eagle* (1971), is a prominent landmark on the horizon. Where the promenade meets Puget Sound, Seattle-based artist Roy McMakin sited *Love & Loss* (2005–2006), a grouping of concrete furniture elements and a tree wittily painted to spell the words of its title when viewed from specific angles.

As one might expect in Seattle, this crucible for new communication systems, the infrastructure of the path has been designed to include continuous power, water, and teledata so that artists may in the future create works that use advanced technologies.

Site-specific commissions include Mark Dion's *Neukom Vivarium* (2003–2004) which necessitated the construction of a second pavilion, a greenhouse sheltering a sixty-foot-long nurse log, a fallen hemlock that is deliberately allowed to rot. Visitors can use magnifying glasses to closely inspect the log's decay as well as the growth of new life. In this setting, the organic and the rationalistic come together, nature and construction, almost like a distillation of the park itself. In the future, other structures might perhaps be added to the park.

Teresita Fernández's site-specific contribution is *Seattle Cloud Cover* (2004–2006) a glass screen wall and canopy on the bridge that traverses the active train tracks. Color-saturated images based on digital photographs of the Seattle sky have been inserted between layers of the glass. Sheltering the pedestrian route and providing a point of bright color in the landscape, the bridge fuses infrastructure with sensory engagement.

A primary aim of the Olympic Sculpture Park is to help restore the nature of the site, in particular the aquatic life of Puget Sound. Scientists from the University of Washington are tracking the water and seabed for signs of life returning to this area after decades of industrial pollution. As suggested in Weiss/Manfredi's earliest concept sketches, the ultimate success of the Olympic Sculpture Park will be measured not only by the large numbers of visitors but by reestablishing a healthy balance between human activity and the world of nature.

→ View through Richard Serra's *Wake* (2004) in Olympic Sculpture Park

1 Lisa Corrin , in *Olympic Sculpture Park* (Seattle, WA: Seattle Art Museum, 2007), 26.
2 Weiss/Manfredi, quoted in Joan Busquets, *Olympic Sculpture Park for the Seattle Art Museum* (Cambridge, MA: Harvard University Graduate School of Design, 2008), 29.

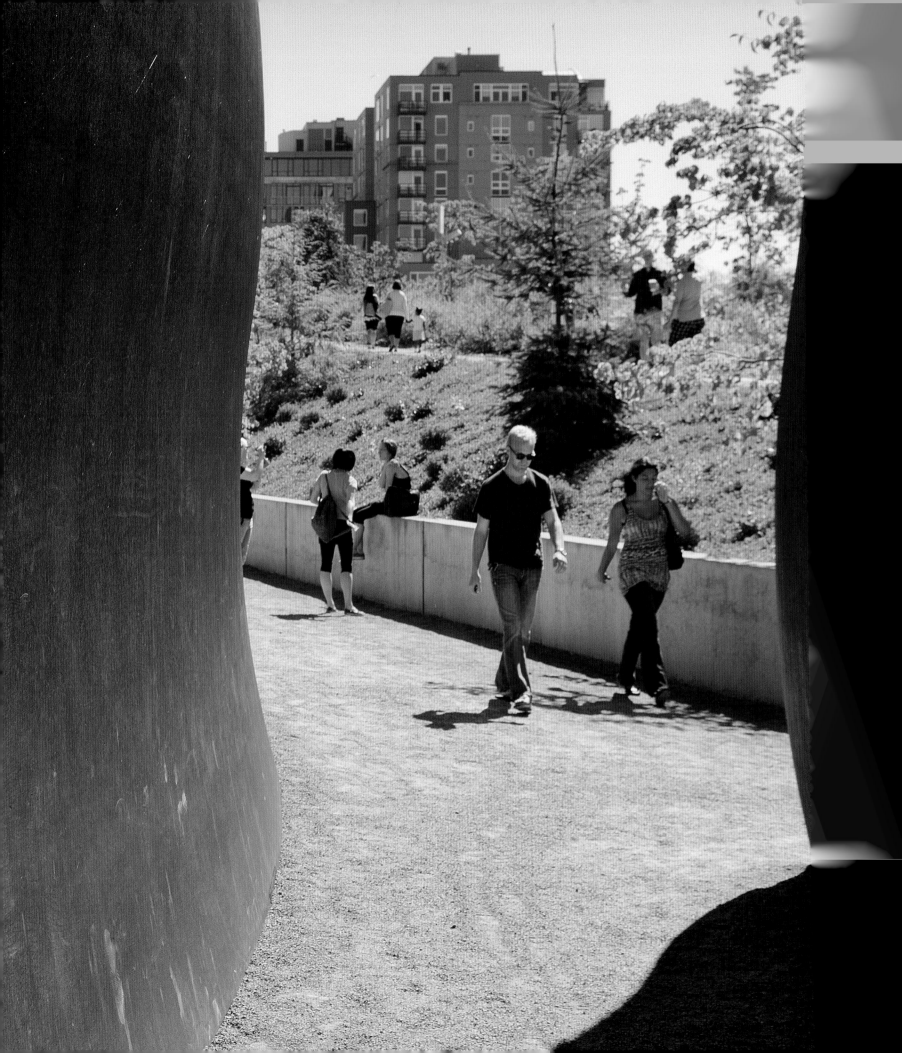

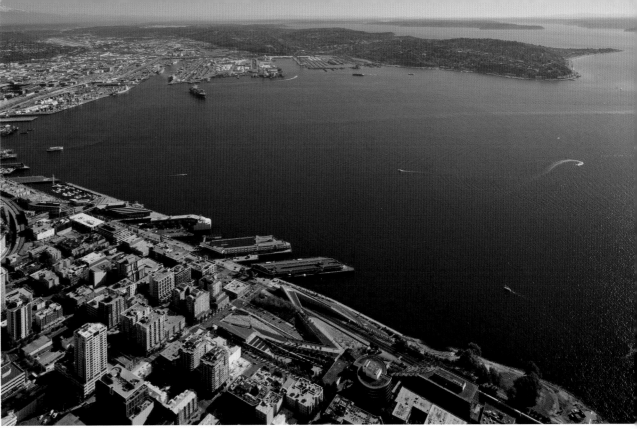

← Aerial view looking northeast across the Olympic Sculpture Park, including the Space Needle

↑ Top: Aerial view of Seattle looking southwest across Puget Sound

Bottom: Sketch by Weiss/Manfredi of Olympic Sculpture Park

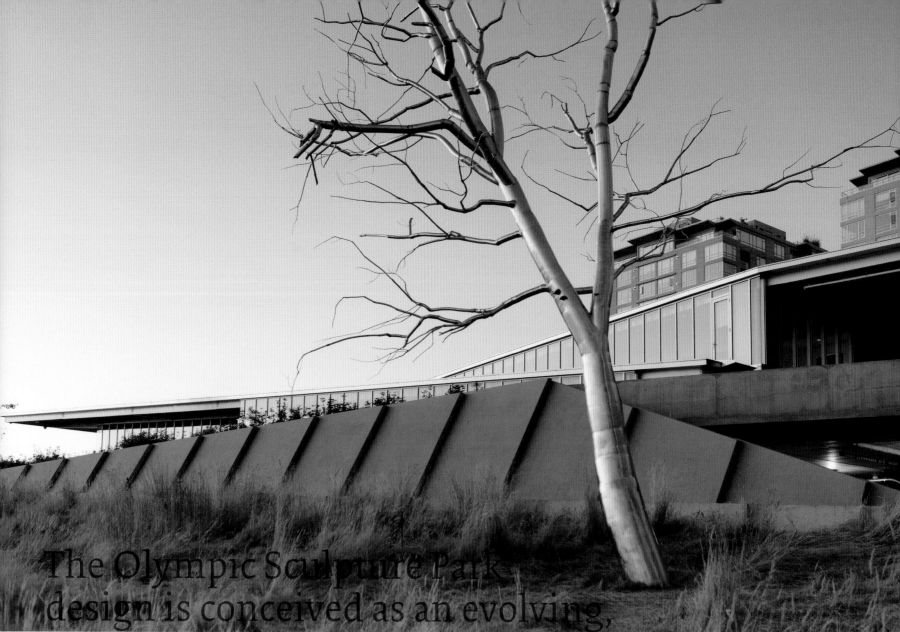

The Olympic Sculpture Park
design is conceived as an evolving,
intentionally mutable model that
can respond to an extraordinary
range of artistic practices, past and
present, as well as to future artistic
interventions. The artistic program
is equally open-ended.

Lisa Corrin, *Formerly Deputy Director of Art, Seattle Art Museum*

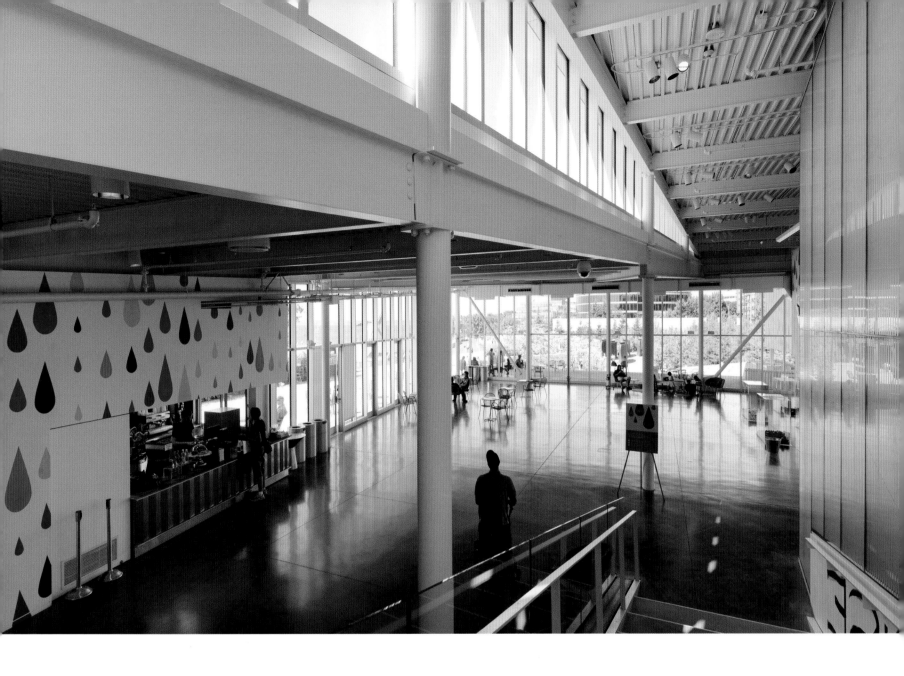

↖ Exterior of PACCAR Pavilion by Weiss/
Manfredi, with Roxy Paine's *Split* (2003) in
foreground

↑ Interior of PACCAR Pavilion, with part
of Trenton Doyle Hancock's installation
A Better Promise (2010–2012) at left

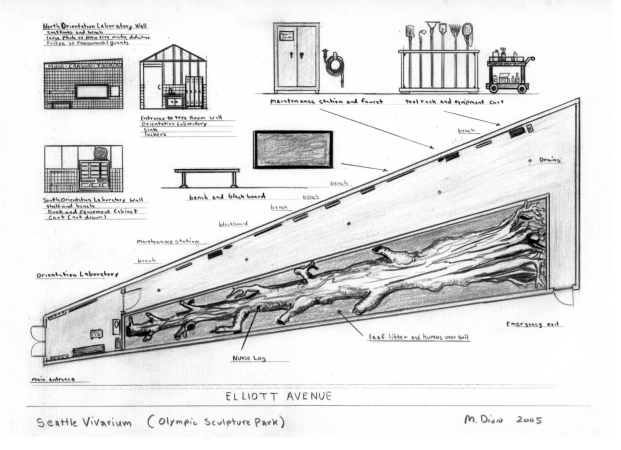

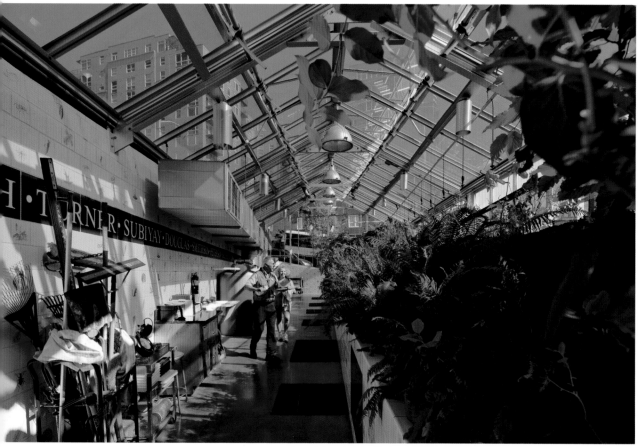

↑ Top: Preparatory sketch by Mark Dion of *Neukom Vivarium* (2003–2004), Seattle Art Museum

Bottom: Interior of Mark Dion's *Neukom Vivarium* (2003–2004)

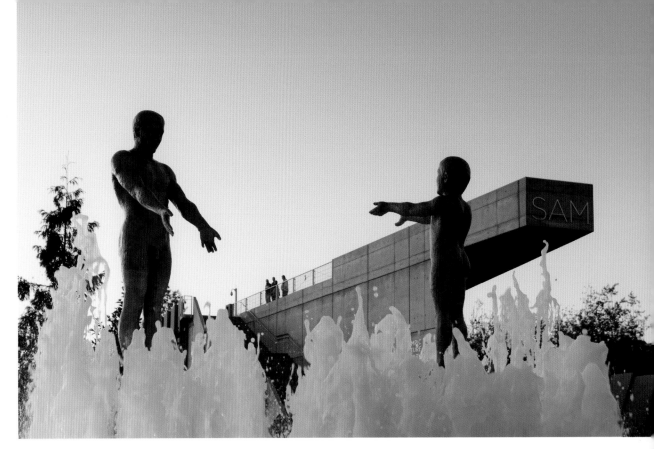

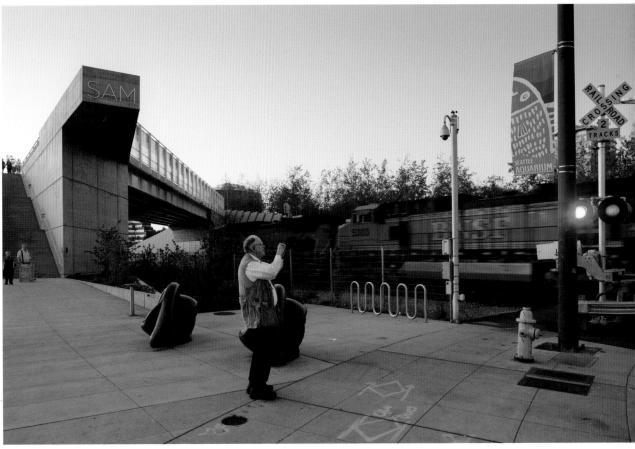

↑ Top: Louise Bourgeois's *Father and Son* (2004–2006)

Bottom: View from Broad Street showing freight train, bridge, and Louise Bourgeois's *Eye Benches* (1996–1997)

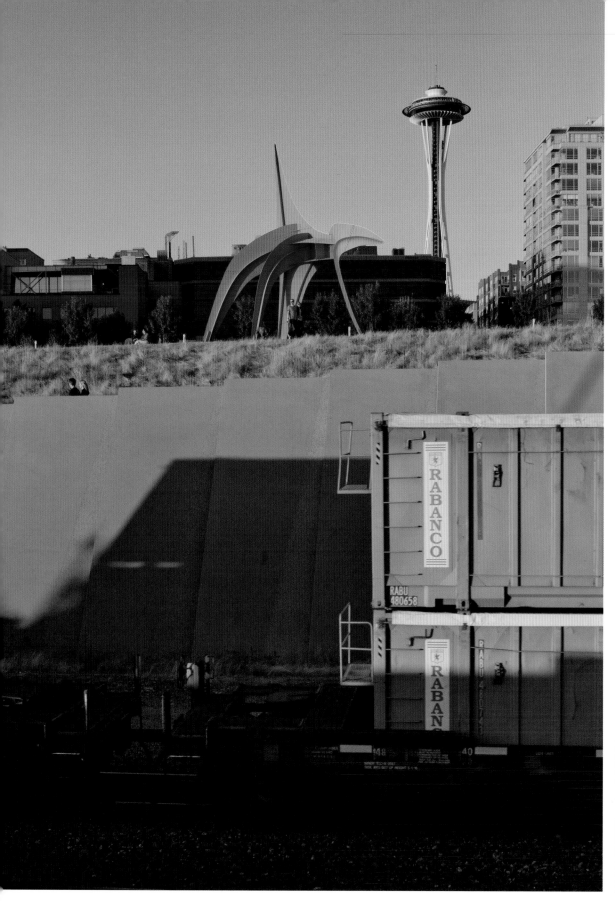

↑ View across train tracks to Alexander
 Calder's *Eagle* (1971) and the Seattle Space
 Needle, built for the 1962 world's fair

↗ Top: Exterior of PACCAR Pavilion

Bottom: Bridge over railway with Teresita
Fernández's *Seattle Cloud Cover* (2004–2006)

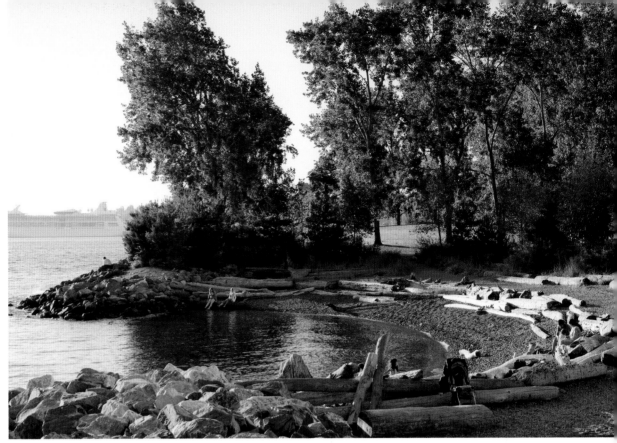

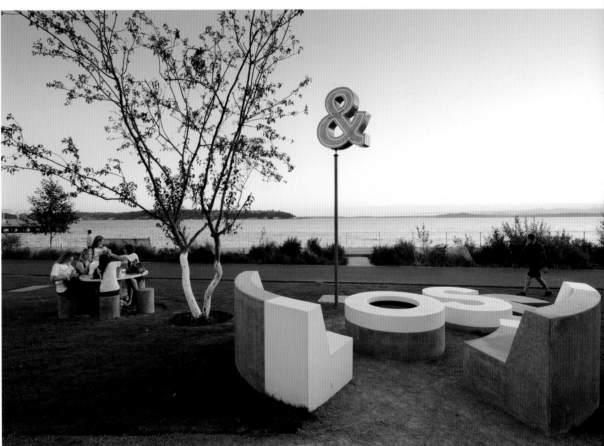

↑ Top: View of the Pocket Beach on Elliot Bay, Puget Sound

Bottom: Roy McMakin's *Love & Loss* (2005–2006), with view to Puget Sound

Name of Institution
Olympic Sculpture Park

Area
3.4 hectares (8.5 acres)

Dates
Inaugurated 2006

Client
Seattle Art Museum

Catharina Manchanda, *Curator for Modern and Contemporary Art*

Location
Seattle, Washington, USA

Architects
Weiss/Manfredi
Architecture/Landscape/Urbanism
Marion Weiss and Michael Manfredi
New York, New York

Landscape Architecture Consultant

Charles Anderson Landscape
Architecture
Seattle, Washington

Structural and Civil Engineering
Consultant

Magnusson Klemencic Associates
Seattle, Washington

Geotechnical Engineering Consultant

Hart Crowser
Seattle, Washington

Lighting Design Consultant

Brandston Partnership Inc.
New York, New York

Buildings

PACCAR Pavilion (2006)
Architect: Weiss/Manfredi

Neukom Vivarium (2003–2004)
Artist: Mark Dion

Selected Artists
Louise Bourgeois
Eye Benches I, II and III (1996–1997),
Father and Son (2004–2006)

Alexander Calder
Eagle (1971)

Anthony Caro
Riviera (1971–1974)

Mark Dion
Neukom Vivarium (2003–2004)

Mark di Suvero
Bunyon's Chess (1965),
Schubert Sonata (1992)

Teresita Fernández
Seattle Cloud Cover (2004–2006)

Ellsworth Kelly
Curve XXIV (1981)

Roy McMakin
Untitled (2007),
Love & Loss (2005–2006)

Louise Nevelson
Sky Landscape 1
(1976–1983)

Claes Oldenburg
and Coosje van Bruggen
Typewriter Eraser, Scale X (1998–1999)

Roxy Paine
Split (2003)

Beverly Pepper
Persephone Unbound (1999),
Perre's Ventaglio III (1967)

Richard Serra
Wake (2004)

Tony Smith
Wandering Rocks (1967–1974),
Stinger (1967–1968/1999)

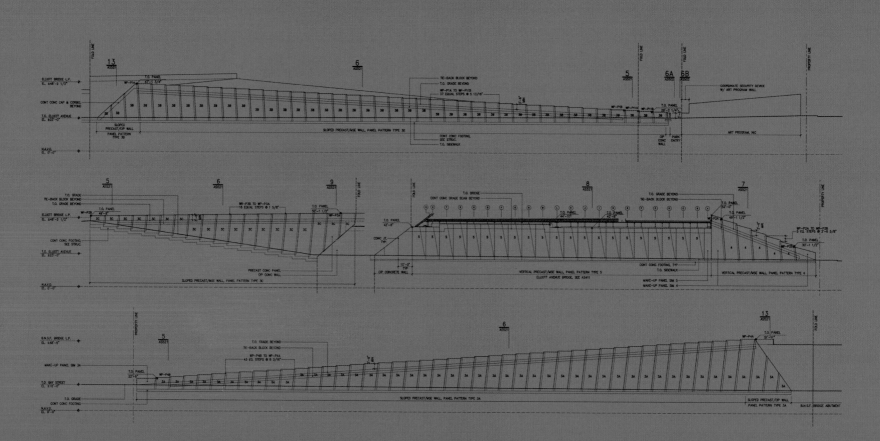

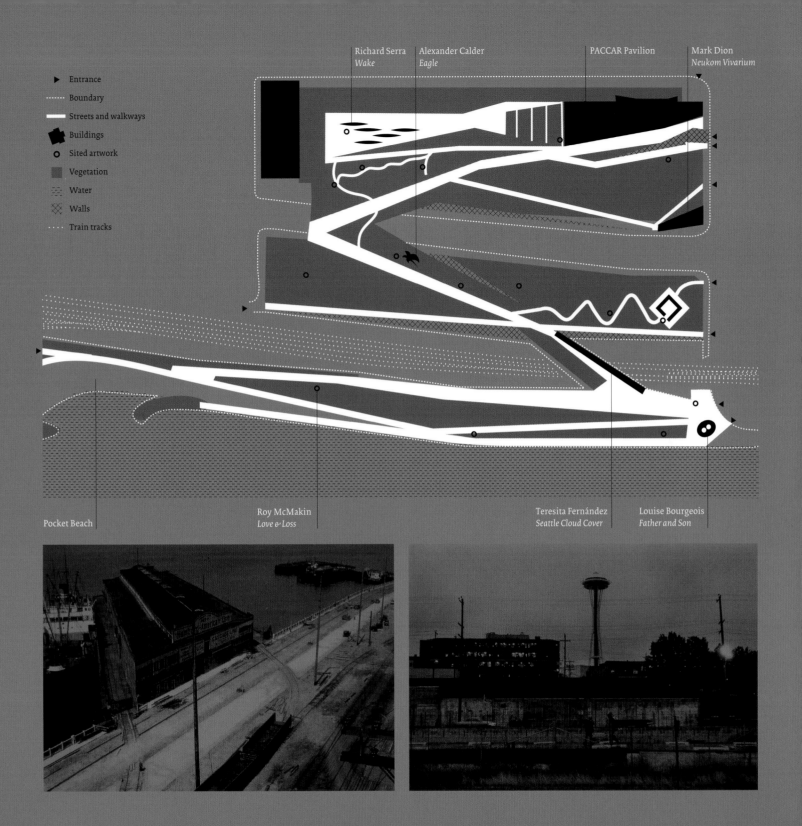

Richard Serra
Wake

Alexander Calder
Eagle

PACCAR Pavilion

Mark Dion
Neukom Vivarium

Entrance
Boundary
Streets and walkways
Buildings
Sited artwork
Vegetation
Water
Walls
Train tracks

Pocket Beach

Roy McMakin
Love & Loss

Teresita Fernández
Seattle Cloud Cover

Louise Bourgeois
Father and Son

↑ Top: Site plan of Olympic Sculpture Park

Bottom Left: Historic photograph of the Seattle
waterfront, 1936

Bottom Right: *Travelers*, photograph of the site,
1986

← Drawing by Weiss/Manfredi of concrete
retaining walls

Stiftung Insel Hombroich
North Rhine-Westphalia, Germany

This ongoing project consists of three major components: Insel Hombroich, Raketenstation Hombroich, and spaceplacelab. Since the 1980s, Insel Hombroich has been a model for the bucolic integration of art, building, and landscape. The Raketenstation entails the conservation of a former NATO rocket base and the insertion of landmark architectural projects in this surprising milieu. And spaceplacelab is an almost Utopian master plan for live/work strategies on the extensive plain surrounding the decommissioned base.

The Insel Hombroich story began in 1982, when businessman Karl-Heinrich Müller bought an elegant farmhouse, the Rosa Haus, and the surrounding agricultural land with the intention to display his art collection. This proposal to display art and artifacts developed with the support of local artists, most importantly the sculptor Erwin Heerich, whose ideas became the design basis for the first galleries; landscape architect Bernhard Korte, who restored the gardens; and Gotthard Graubner, who developed the exhibition concept.

Some years after the completion of Insel Hombroich, the first phase of an evolving project incorporating disparate aspects of the German landscape, Müller wrote, "Hombroich is not only a question of building. It is a question of the architecture of life, a question of structures and, the meaning of all forms of life."[1]

The site is close to Cologne and Dusseldorf yet feels distant from such busy conurbations. Visitors pay a single entrance fee and are then free to wander at will throughout the property. Farmland has been carefully allowed to return to a pre-agricultural state, making the visitor aware of seasonal changes in vegetation and the presence of wildlife. One artist, Anatol Herzfeld, continues to operate a studio where visitors may observe sculpture being created. There is also a free canteen serving fresh organic food.

Heerich's pavilions are constructed of local brick; their interiors are almost uniformly white and are illuminated through skylights. There are no guards. The art is displayed without labels or didactic text. This absence of direct information is intended to allow the viewer to see and respond to artwork without being influenced by external factors. Visitors experience a wide array of art from many different cultures and time periods: German Expressionist paintings, Renaissance works, Khmer bronze heads, and Chinese artifacts.

In 1994, Müller bought Raketenstation Hombroich, a thirty-two-acre NATO rocket-launching base only a short walk from Insel Hombroich. During the Cold War, three hangars housed three missiles each. Rather than completely altering this flat expanse of land and disregarding its military past, Müller and his followers have created an unusual landscape by combining old and new. Serpentine earth berms, hangars, and an observation tower have been preserved and repurposed. New buildings are incorporated into this setting as robust elements in their own right.

This postindustrial military complex contains new structures by Erwin Heerich and the active studios of artists Oliver Kruse and Katsuhito Nishikawa, housed in refurbished NATO sheds. Nishikawa has realized a major artwork called *Tilapia* (1996–2001) toward the center of the site. However, the largest interventions are signature works by three contemporary master architects: Tadao Ando, Álvaro Siza Vieira, and Raimund Abraham.

Tadao Ando is responsible for the Langen Foundation with its dramatic concrete wall forming an abstract forecourt, an upper pavilion wrapped in glass, and subterranean galleries. The Foundation is an independent institution located in the Raketenstation and operating within the Hombroich cultural environment. Approached across a generous reflecting pool, Ando's exhibition halls house the collection of traditional Japanese and contemporary Western art amassed by local entrepreneurs Marianne and Viktor Langen. As with his buildings on Naoshima, Ando has devoted great care to ensure an optimal finish to the exposed concrete surfaces.

Originally intended as an Institute for Biophysics, the Siza Pavilion realized in collaboration with Bavarian architect Rudolf Finsterwalder houses the architecture institute and photography archives. It recalls the Heerich pavilions at Hombroich, as well as the Lange and Esters Houses (1927–1930) by Ludwig Mies van der Rohe in nearby Krefeld, in its use of simple materials, especially brick; in its planarity; and in its reticent rhetoric. Unlike Heerich's stark structures, however, Siza's pavilion deforms or inflects in response to the landscape and more complex program. To either end of a long brick spine are a U-shaped gallery and a small photographic archive. The gallery forms a protected courtyard looking north across the plain and is used for architectural exhibitions; it is punctured by two large windows allowing for cross-views.

Müller's vision for the Raketenstation included artists of various disciplines. Raimund Abraham's soon-to-be completed House for Musicians provides musicians with apartments, common space, a library, and a room for events. This cylindrical concrete building shelters an outdoor performance space and is capped by an inclined roof raised on pillars so that it appears to hover. A large equilateral triangle in the roof gives the structure a lighter presence and an iconic identity. Tragically, Abraham died in a car crash in Los Angeles before he could see the completed project.

Insel Hombroich aims to blur the boundaries between interior and exterior, art and architecture, the man-made and nature. Müller's belief—his admonition to his fellow humans, especially in the West—was, "we are answerable to nature, or reckless covetousness will devour all of us. We will uphold it, if we support it. Animals and plants are members of our family. We have to raise our protective hand, we have to return their habitat and we have to be aware of our common unity."[2]

The next phase of this ongoing project, still in early stages of development, is titled spaceplacelab, a "laboratory for alternate modes of living." Coordinated by Wilfried Wang of the Berlin practice Hoidn Wang Partner, more than a dozen architects and artists have collaborated to design residences, studios, and exhibition spaces on adjacent forty-acre lots. Participants include Ando, Siza, Abraham, Kruse, Nishikawa, Thomas Herzog, and Adolf Krischanitz.

As elsewhere at Hombroich, only 10 percent of the land may be built upon, with the remaining 90 percent dedicated to nature—to forests, meadows, and orchards. The spaceplacelab site may thus be understood as a living entity with artists and others inhabiting it and working in harmony. Herzog has proposed a combination of energy-efficient courtyard houses and small towers. Kruse's vision is for a giant elliptical structure encircling "a natural landscape of gardens, meadows and woodland."[3]

The thrust of this evolving settlement in the flat north German landscape is a holistic one: it is more to do with sociopolitical vision than with art as expensive commodity.

→ View of Raketenstation with sculptures by Katsuhito Nishikawa and Oliver Kruse (foreground) and the House for Musicians by Raimund Abraham (left)

1 Karl-Heinrich Müller, quoted in *Hombroich spaceplacelab*, ed. Wilfried Wang (Neuss: Stiftung Insel Hombroich, 2004), 18.

2 Ibid., 19.

3 Ibid., 24.

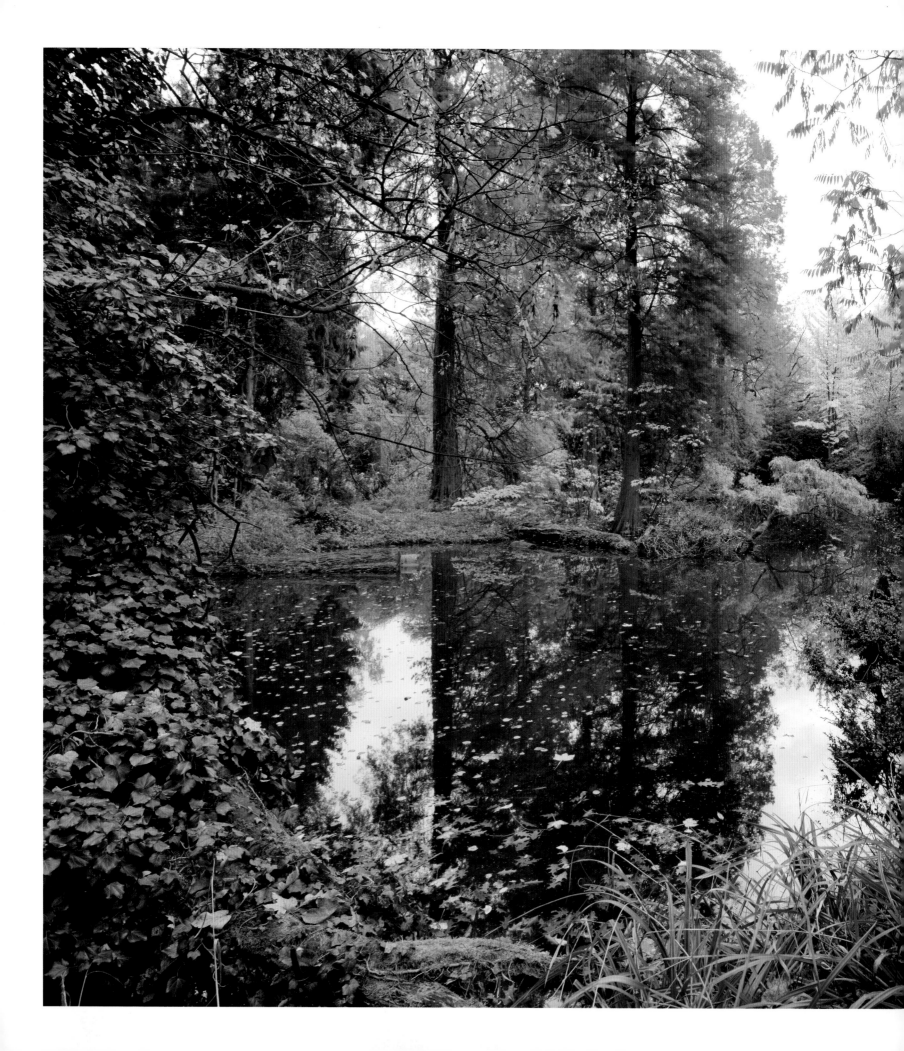

We are answerable to nature, or reckless covetousness will devour all of us. We will uphold it, if we support it. Animals and plants are members of our family. We have to raise our protective hand, we have to return their habitat and we have to be aware of our common unity.

Karl-Heinrich Müller, *Art Collector and Founder*

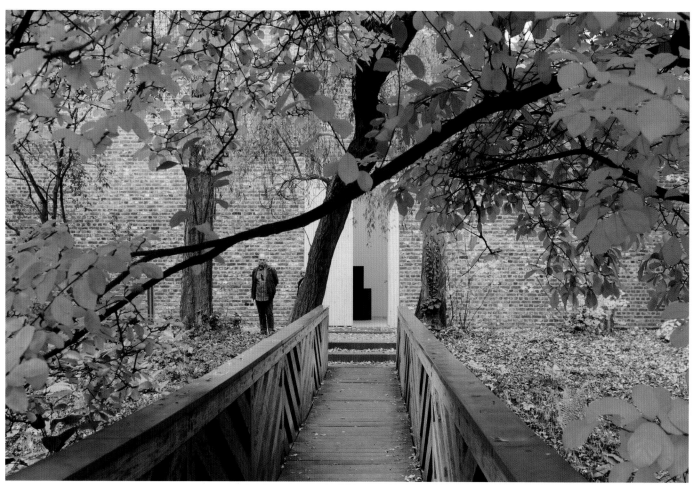

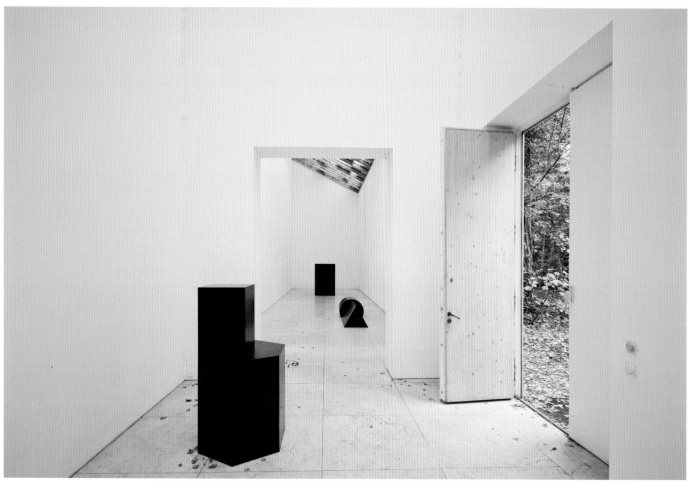

← Top: Wooden bridge leading toward the Hohe Galerie by Erwin Heerich

Bottom: Interior of the Hohe Galerie with sculptures by Erwin Heerich

→ Top: View across reflecting pool to Langen Foundation by Tadao Ando

Bottom: Underground exhibition hall in Langen Foundation

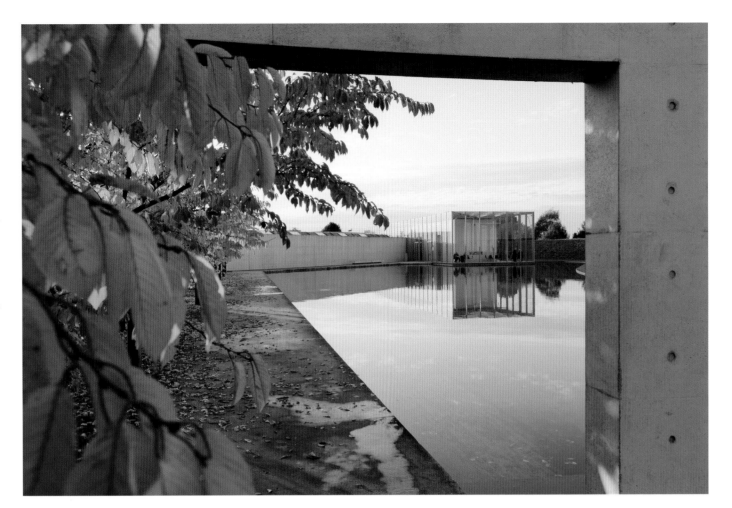

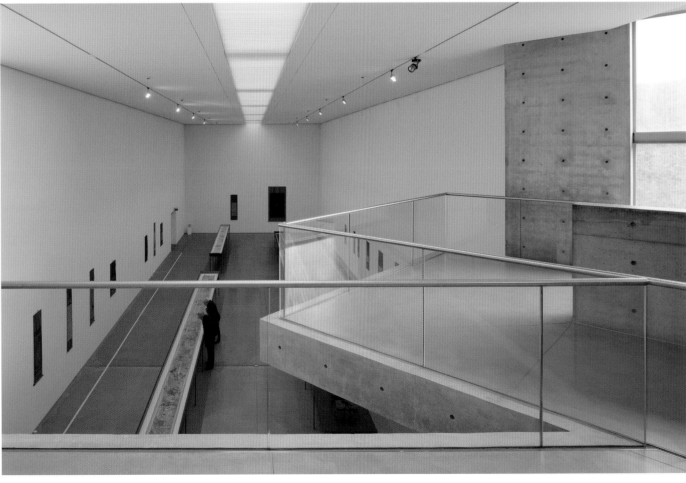

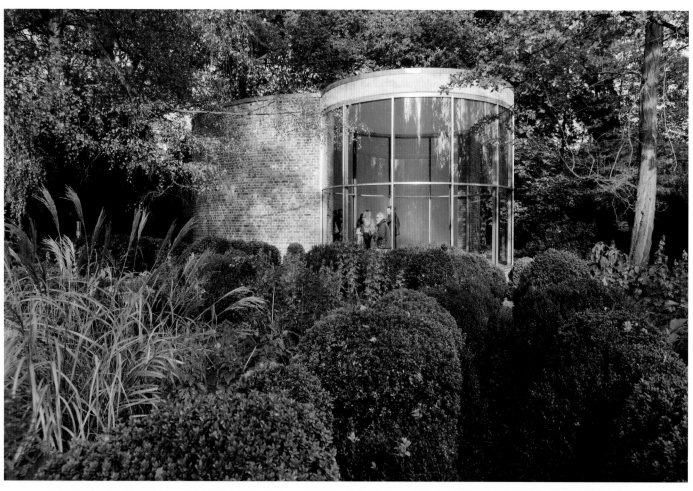

← Top: Gardens at Insel
Hombroich with
Graubner Pavilion
by Erwin Heerich

Bottom: View of
Raketenstation site
through pavilion by
Erwin Heerich

→ Raketenstation with
Heerich pavilions in
distance and House
for Musicians by
Raimund Abraham
(right)

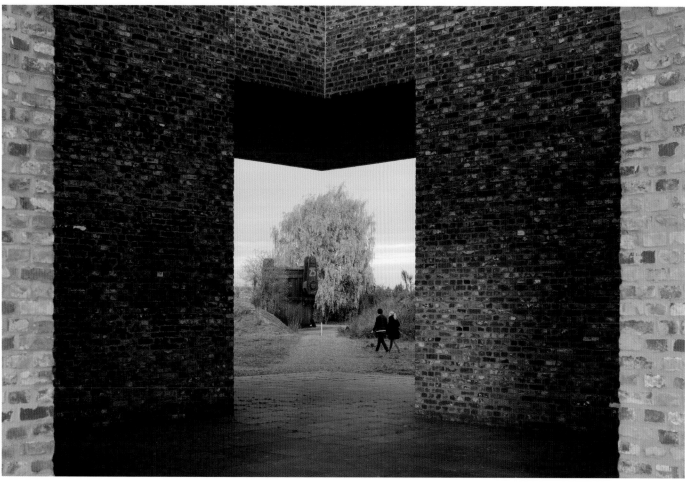

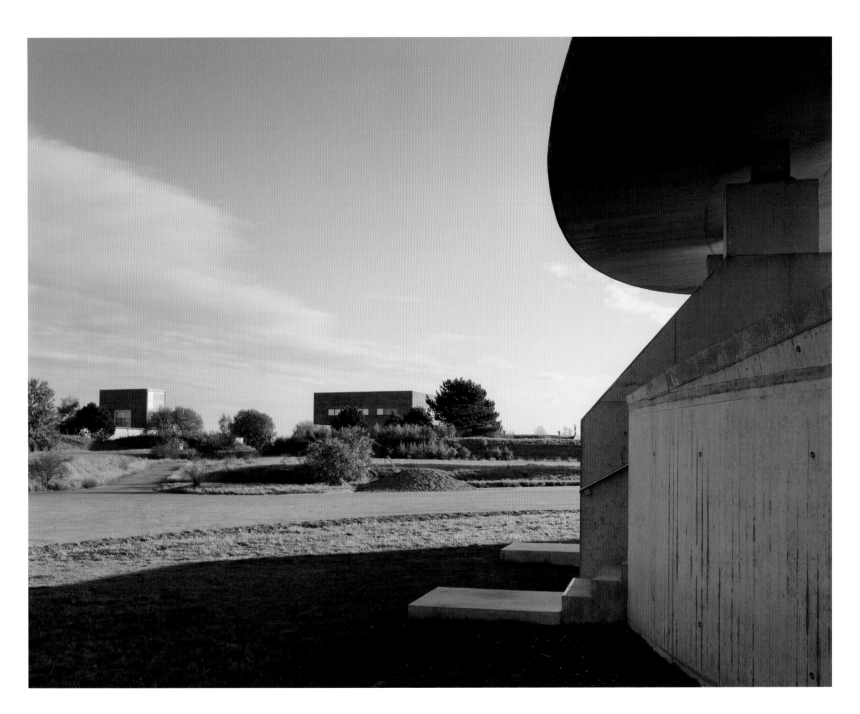

← Sketch by Álvaro Siza Vieira of Siza Pavilion

→ Top: Exterior of Siza Pavilion by Álvaro Siza Vieira and Rudolf Finsterwalder

Bottom: Interior of Siza Pavilion showing archive of maquettes by Erwin Heerich

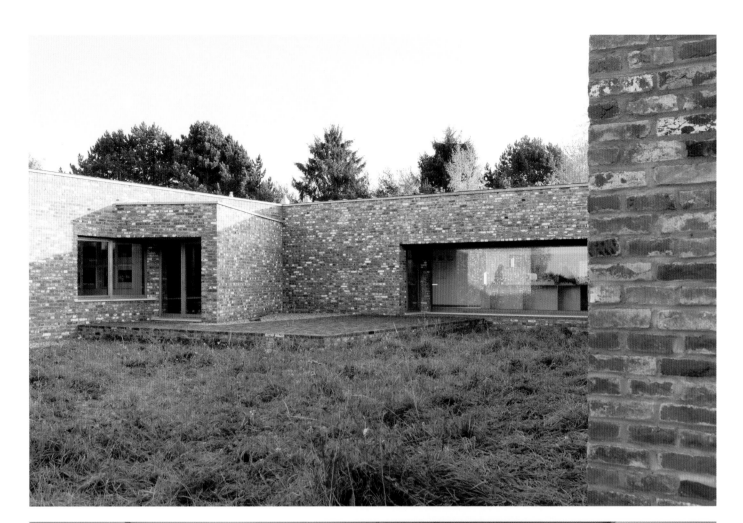

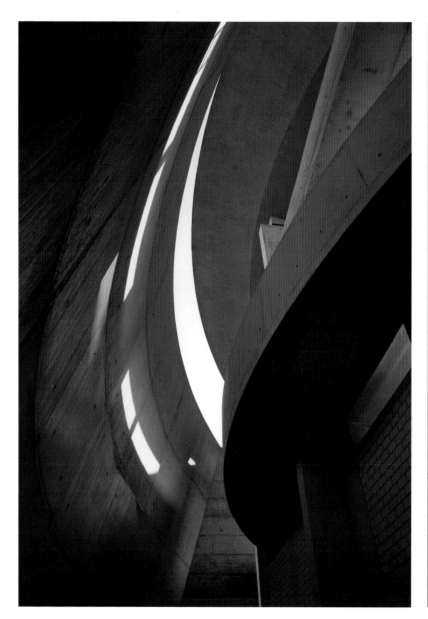
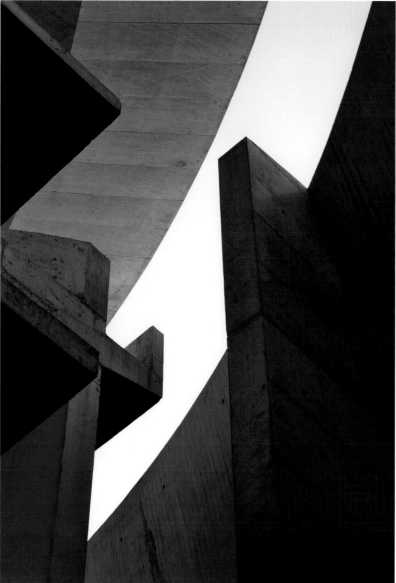

← Raimund Abraham's own photographs of the interior of House for Musicians nearing completion, c. 2010

→ Top: Polyurethane conceptual model by Oliver Kruse of Quarter No.7, spaceplacelab

Bottom: Site plan of spaceplacelab showing fifteen "quarters" and Raketenstation (center)

Name of Institution
Stiftung Insel Hombroich

Location
North Rhine-Westphalia, Germany

Area
Insel Hombroich + Raketenstation
Hombroich: 72 hectares (178 acres)

spaceplacelab: 400 hectares (988
acres)

Dates
Inauguration of Insel Hombroich,
1987

Purchase of Raketenstation site, 1994

Insel Hombroich and Raketenstation
form the Stiftung Insel Hombroich,
1997

Inauguration of spaceplacelab
concept, 2005

Founder
Karl-Heinrich Müller

Director
Ulrike Rose

Phase 1. Insel Hombroich

Architectural Designer
Erwin Heerich
Kassel, Germany

Landscape Architects
Bernhard Korte
Grevenbroich, Germany

Burkhard Damm
Hombroich, Germany

Notable Buildings
—All by Erwin Heerich, unless
otherwise noted

Ticket Pavilion

Tower

Labyrinth (1985–1986)
Art: Khmer sculptures; Chinese
furniture and objets d'art; twentieth-
century artists including Jean Arp,
Lovis Corinth, Jean Fautrier, Gotthard
Graubner, Erwin Heerich, Francis
Picabia, and Kurt Schwitters

Anatol's House
Architect: Anatol Herzfeld

Hohe Galerie (1983)
Art: Erwin Heerich

Graubner Pavilion (1983)
Art: Gotthard Graubner

Orangerie
Art: twelfth- and thirteenth-century
Khmer sculptures

Rosa Haus (1816), Literature & Art
Institute (unknown designer)

Concert Barn

Kindergarten (no public access)
Architect: Oliver Kruse

Tadeusz Pavilion
Art: Norbert Tadeusz

Twelve-Room House
Art: objects from Africa, Oceania,
Mexico, Peru, China, Persia, and
Cambodia; twentieth-century artists
including Marcel Breuer, Alexander
Calder, Eduardo Chillida, Erwin
Heerich, Anatol Herzfeld, Alfred
Jensen, Yves Klein, Oliver Kruse,
Henri Matisse, Gerrit Rietveld,
Norbert Tadeusz, and Bart van der
Leck.

Schnecke (graphics gallery)

Cafeteria

Phase 2. Raketenstation

Architects/Architectural Designers
Raimund Abraham
New York, New York

Tadao Ando Architect & Associates
Tadao Ando
Osaka, Japan

Erwin Heerich
Kassel, Germany

Oliver Kruse
Hombroich, Germany

Katsuhito Nishikawa
Hombroich, Germany

Claudio Silvestrin architects
Claudio Silvestrin
London, England

Arquitecto Álvaro Siza Vieira
Álvaro Siza Vieira
Porto, Portugal

Finsterwalderarchitekten
Rudolf Finsterwalder
Stephanskirchen, Germany

Landscape Architects
Bernhard Korte
Grevenbroich, Germany

Burkhard Damm
Hombroich, Germany

Notable Buildings
Langen Foundation (2004)
Architect: Tadao Ando

Siza Pavilion (2004)
Architect: Álvaro Siza Vieira and
Rudolf Finsterwalder

Studio – Katharina Hinsberg

Das Böhmische Dorf – Oswald Egger

Field Institute Hombroich –
Containertunnel
Architect: Katsuhito Nishikawa

House for Musicians
Architect: Raimund Abraham
(nearing completion)

One-Man-House
Architect: Katsuhito Nishikawa

Turmskulptur / Tower Sculpture
Architect: Erwin Heerich

Studios – Katsuhito Nishikawa +
Oliver Kruse

Studio Apartments
Architect: Erwin Heerich

Archive / Seminar Building
Architect: Erwin Heerich

Cloister / Guesthouse (2000)
Architect: Erwin Heerich

Cloister Garden

Organization Hall
Interior design: Claudio Silvestrin

Fontana Pavilion (2000)
Architect: Erwin Heerich

Selected Artists
Eduardo Chillida
Begiari (2000)

Per Kirkeby
3 Kappellen (2002)

Katsuhito Nishikawa
Tilapia (1996–2001),
Cloister garden (2002–2007),
Physalis (1998–2000)

Phase 3. spaceplacelab

Masterplan
Hoidn Wang Partner
Barbara Hoidn, Wilfried Wang
Berlin, Germany

Architects/Architectural Designers
Raimund Abraham
New York, New York

Tadao Ando
Osaka, Japan

Rudolf Finsterwalder
Stephanskirchen, Germany

Erwin Heerich
Kassel, Germany

Thomas Herzog
Munich, Germany

Per Kirkeby
Læsø, Denmark

Adolf Krischanitz
Vienna, Austria

Oliver Kruse
Hombroich, Germany

Daniel Libeskind
New York, New York

Katsuhito Nishikawa
Hombroich, Germany

Frei Otto
Stuttgart, Germany

Claudio Silvestrin
London, England

Álvaro Siza Vieira
Porto, Portugal

Wilfried Wang
Berlin, Germany

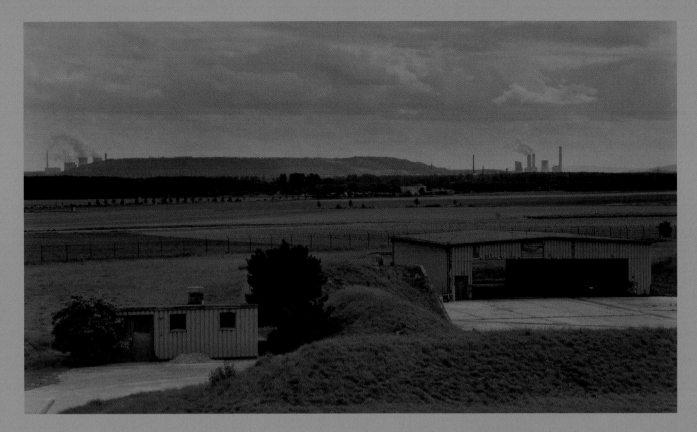

→ Historic photograph
of Raketenstation site

↓ Left: Site plan of
Raketenstation

Right: Site plan of
Insel Hombroich

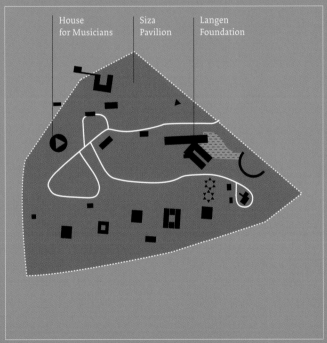

House
for Musicians

Siza
Pavilion

Langen
Foundation

▶ Entrance

‥‥‥ Boundary

▬▬▬ Streets and walkways

◼ Buildings

▦ Vegetation

▦ Water

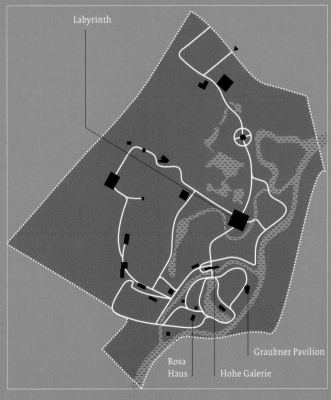

Labyrinth

Graubner Pavilion

Rosa
Haus

Hohe Galerie

Benesse Art Site Naoshima
Kagawa and Okayama Prefectures, Japan

Several islands in Japan's Seto Inland Sea have become the site of ambitious art projects initiated by Benesse Holdings. These scenic islands are home to small communities largely consisting today of an aging and declining population. In addition, during the twentieth century, the islands were damaged in several locations by heavy industry and pollution. The Benesse Art Site Naoshima aims to revitalize the region, working initially on Naoshima and later on adjacent islands such as Inujima and Teshima.

Headquartered in Okayama, Benesse's companies operate in the education, language instruction, and health care fields. Regarding the corporation's patronage on Naoshima, Director Soichiro Fukutake has said, "I would like to send out a message to the world, a new view of civilization for the twenty-first century: *Use what exists to create what is to be.*" [1]

Benesse interventions thus include both robust new structures and radical interventions into existing buildings. Its initial endeavor, in 1989, established a children's camp on Naoshima. At that time, according to famed Osaka architect Tadao Ando, "the island was covered by bare hills that had had all of their greenery destroyed from sulfurous acid gas." [2] In subsequent decades, much reforestation has occurred and Ando has erected a half-dozen structures in the south of the island that both provide visitor accommodation and present contemporary art in a spectacular natural setting.

The first building to be realized was Benesse House, in 1992, a museum with a hotel. Visitors approach via a sloped walkway and enter a cylindrical exhibition space surrounded by galleries, dining facilities, and an outdoor sculpture court. In 1995, Ando completed the Oval, a hilltop annex with oval courtyard reached from Benesse House Museum by monorail. Open to the sky and containing a large oval pool, the courtyard is surrounded by guest rooms with views focused out to sea.

Below Benesse House Museum is a grand terrace with panoramic sea views; a work by sculptor Walter De Maria is sheltered beneath. In 2006, Ando added two hotel blocks—Park and Beach—on the former location of the children's camp. Whereas the earlier Ando projects dug into the earth and were constructed primarily with concrete and stone, these later designs explore the qualities of wood and have a lighter expression.

Completed in 2004, the Chichu Art Museum is sited emphatically below grade (*chichu* can be translated as "underground" or "in the earth"). Visitors enter through a long hallway to emerge into a sunken courtyard where large concrete walls emphasize a sense of being within the earth. Galleries are dedicated to specific works by three artists: Claude Monet, Walter De Maria, and James Turrell. Skylights permit light to filter in and allow weather and natural illumination to affect the visitors' experience of the art. The floor of the Claude Monet Space is laid in small cubes of brilliant white marble. A nearby garden is designed to recall Monet's famous garden at Giverny outside Paris.

In 2010, Ando completed another museum building in a small valley between the Chichu Art Museum and Benesse House Museum. Dedicated to the Korean/Japanese artist Lee Ufan, this structure is situated partially underground in a hollow looking out to sea. Visitors access the museum by traversing a large concrete plaza. Displaying

sculptural works by Ufan from the 1970s to the present, the galleries are lit by dramatic narrow skylights.

In Honmura, one of three villages on Naoshima, the Art House Project is a series of permanent installations launched in 1998. Artists and architects have transformed abandoned houses into artworks that build upon the space, history, and memory of the place. For example, Ando and James Turrell collaborated on the project named *Minamidera* after the temple that once stood on the site. Other Art House Projects have been realized by artists such as Tatsuo Miyajima, Rei Naito, and Hiroshi Sugimoto. Local residents engage with the Art House Project by acting as docents and managers.

The Naoshima Ferry Terminal at Miyanoura port is the main point of access to the island. This elegant structure, designed by Tokyo-based architecture firm SANAA (Sejima and Nishizawa and Associates), was completed in 2006. Delicate columns support a thin, flat roof that provides shelter for cars and a glass-enclosed waiting area and café.

On Inujima, a sixty-minute boat ride away, Hiroshi Sambuichi has transformed the *seirensho*, an abandoned copper refinery. The Hiroshima-based architect has memorialized Inujima's industrial heritage by respecting the ecology of the site, reusing brick walls and a dramatic smokestack. An underground passageway with carefully controlled ventilation and illuminated by an ingenious system of mirrors leads to a semi-external hall in which a permanent installation by artist Yukinori Yanagi is housed. In *Solar Rock* (2008), components of the traditional Tokyo residence once occupied by controversial Japanese author Yukio Mishima are suspended and moving slowly in the air.

Also on Inujima, the architect Kazuyo Sejima has to date created four Art House Projects distributed throughout the harbor village. F-Art House is an open wooden structure housing a light sculpture by Yanagi and with amorphous enclosures at either end—mirrored outdoor rooms that provide seismic stability. S-Art House's curving acrylic walls host Yanagi's delicate *Dollar Web Garden* (2010), which is composed primarily of lace. Next to the traditional cemetery, the reflective aluminum alloy roof of Nakanotani Gazebo is perforated by tiny holes. Finally I-Art House is a pavilion set amid flower gardens and animated by a projected image of an eye, another installation by Yanagi.

On the third island, Teshima, a "museum" by architect Ryue Nishizawa and artist Rei Naito opened in late 2010. The organic form of the white concrete structure, inspired by a drop of water, harmonizes with the undulating landscape. Initially, visitors discover a path that meanders through the verdant surroundings before leading to a narrow entrance. Inside, two large apertures pierce the roof, allowing rain, air, and light to enter the space and thus fuse art, architecture, and nature.

These and neighboring islands supplied locations for the Setouchi International Art Festival in 2010. On Teshima, the architect Ryo Abe constructed a swooping canopy of timber shingles to extend a modest restaurant and encircle a small stage and two persimmon trees. Also on Teshima, the German artist Tobias Rehberger patterned the interior of a village house with dramatic stripes and dots to make a café. Thus a temporary educational initiative has expanded to host works by leading architects and artists in the specific maritime context of these southern Japanese islands.

→ Interior of the Claude Monet Space in the Chichu Art Museum by Tadao Ando

1 Soichiro Fukutake, "My Vision of the Seto Inland Sea: Why I Brought Contemporary Art to Naoshima," in *Insular Insight: Where Art and Architecture Conspire with Nature; Naoshima, Teshima, Inujima* (Baden: Lars Müller, 2011), 28.
2 Tadao Ando, "A Powerful Message from Naoshima," *Naoshima Note*, no. 3 (2011): 2.

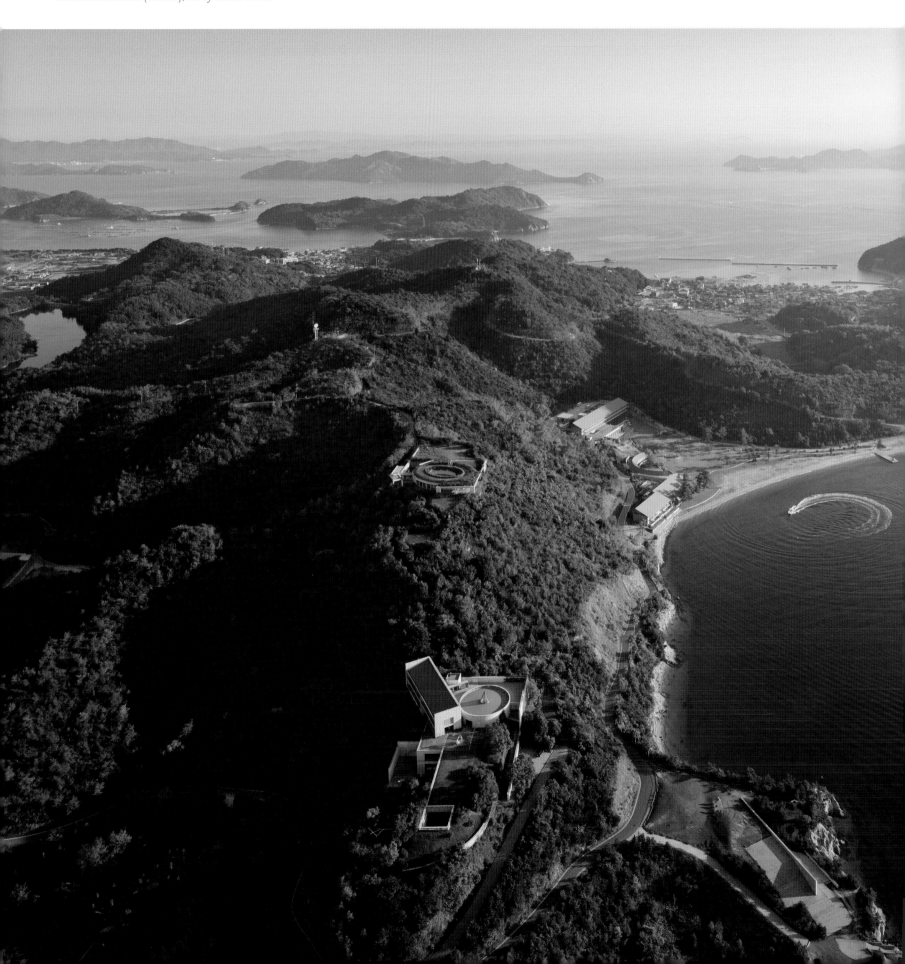

↓ Aerial view of Naoshima showing Benesse House
 Museum and Oval (foreground) and Park
 and Beach Hotels (center), all by Tadao Ando

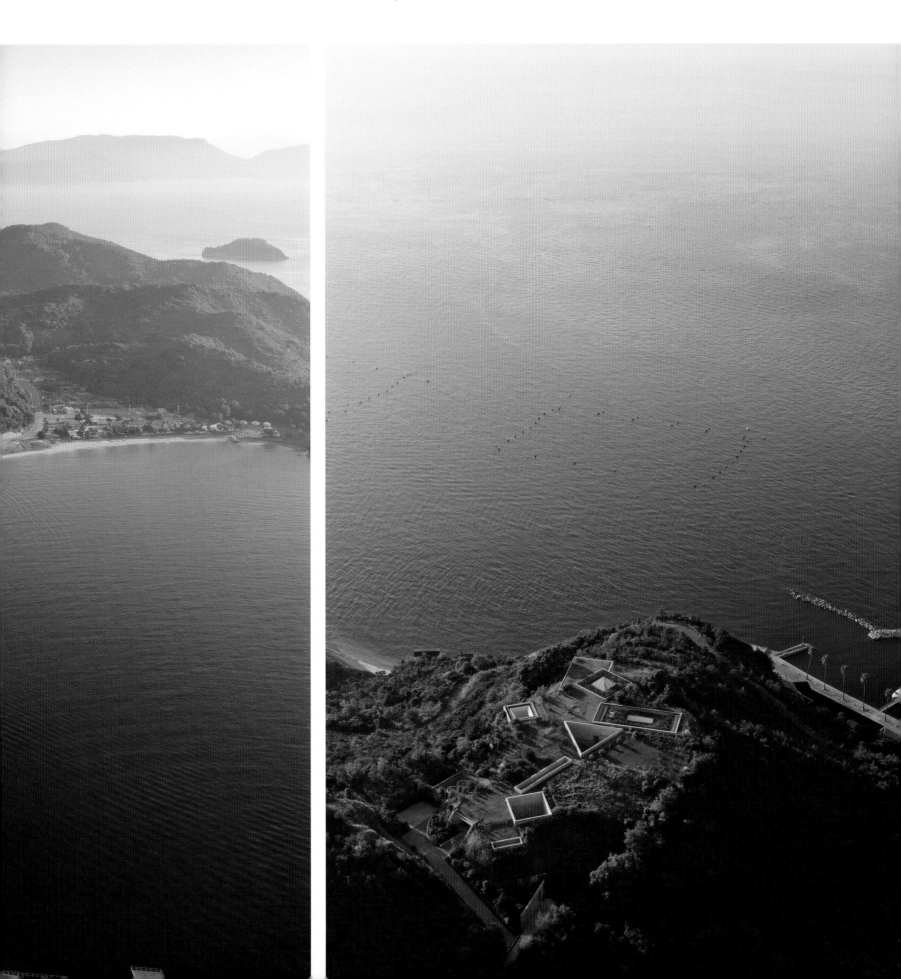

↓ Aerial view of Chichu Art Museum by
Tadao Ando, Naoshima

I would like to
send out a message
to the world,
a new view
of civilization for
the twenty-first
century: *Use what
exists to create
what is to be.*

Soichiro Fukutake, *Director*

↙ Reflecting pool and large oculus in the Benesse House Oval

↓ Benesse House Museum terrace with Hiroshi Sugimoto photographs exhibited outdoors

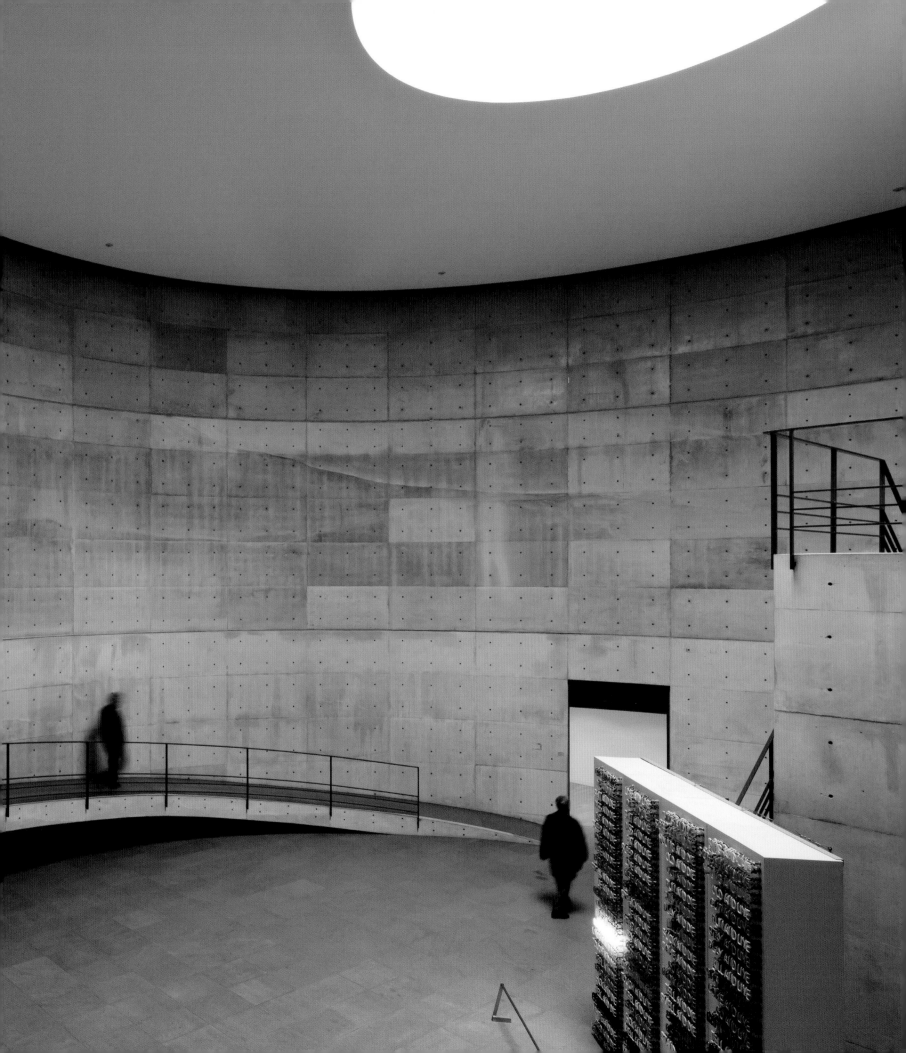

↓ Top: Interior of Art House Project *Kadoya* by Tatsuo Miyajima, Honmura, Naoshima

Bottom: Interior of Energy Hall in *Seirensho* by Hiroshi Sambuichi, with Yukinori Yanagi's installation *Solar Rock* (2008), Inujima

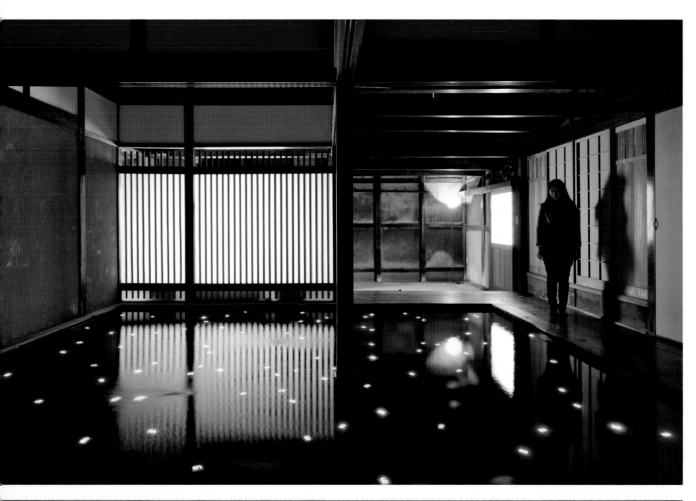

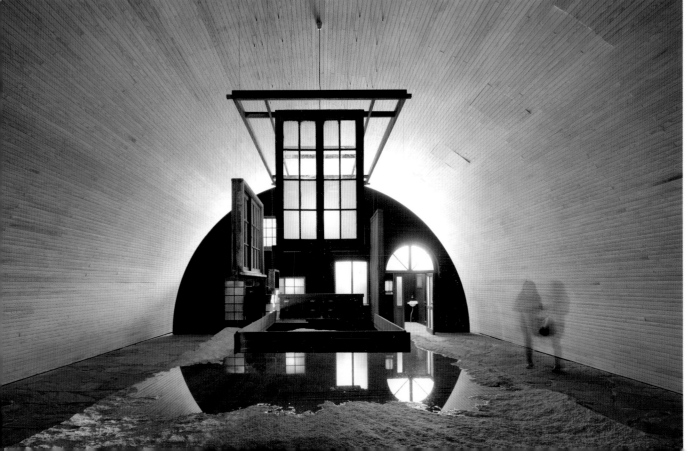

↓ Top: Exterior of S-Art House by Kazuyo
Sejima, with Yukinori Yanagi's installation
Dollar Web Garden (2010), Inujima

Bottom: Interior of F-Art House by Kazuyo
Sejima, with installation by Yukinari Yanagi
(2010), Inujima

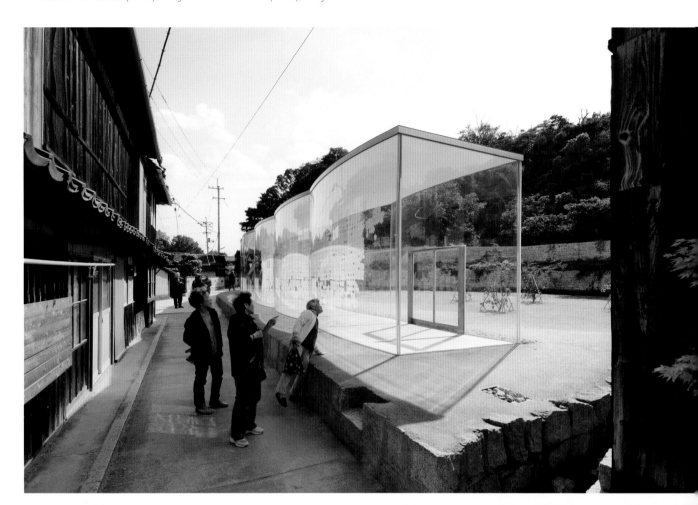

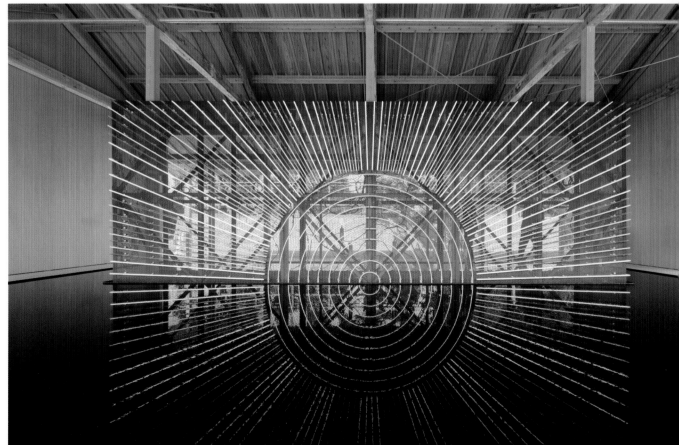

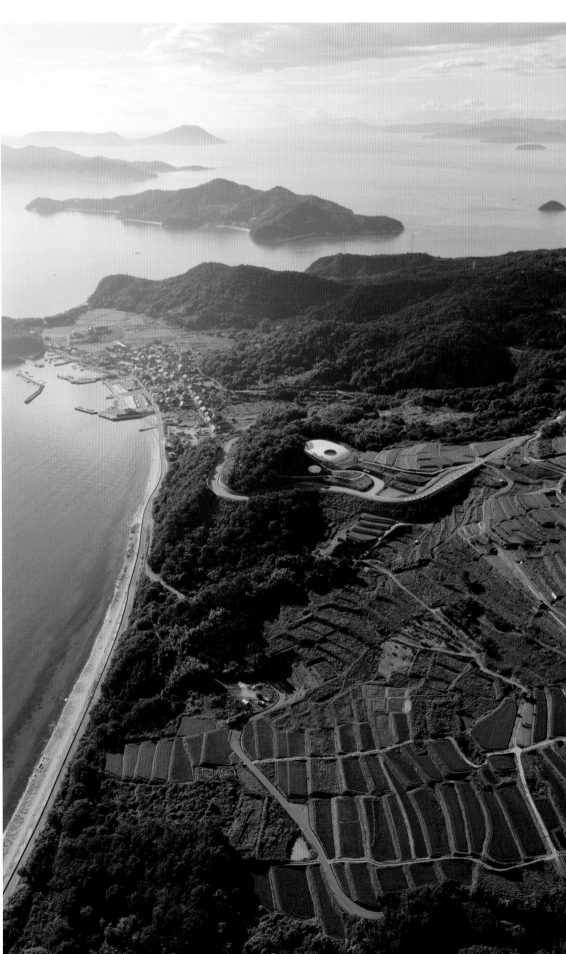

↓ Top: Serpentine path leading to Teshima Art Museum

Top: Forecourt of Lee Ufan Museum by Tadao Ando, Naoshima

Bottom: Exterior of F-Art House by Kazuyo Sejima, Inujima

Bottom: Mariko Mori's *Tom Na H-iu* (2010) in a secluded wooded area of Teshima

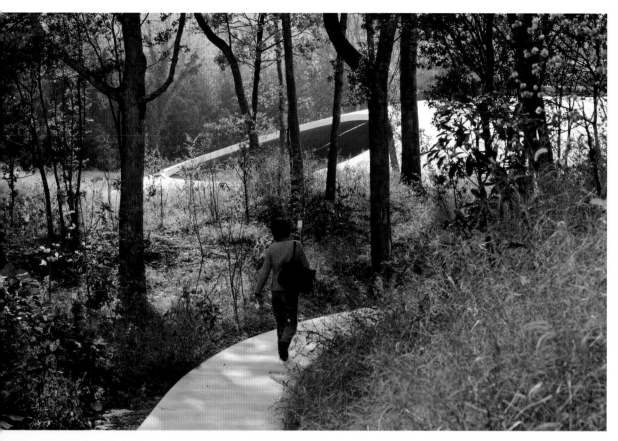

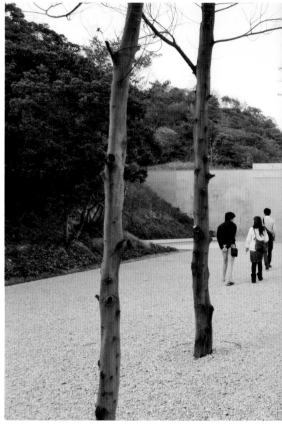

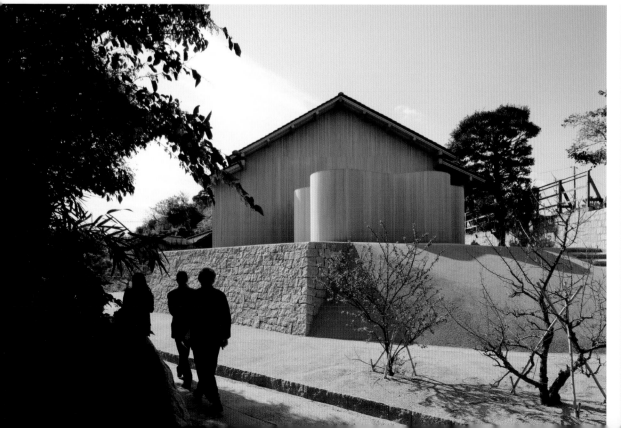

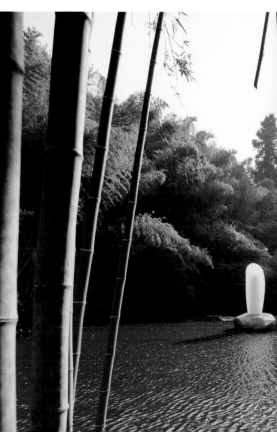

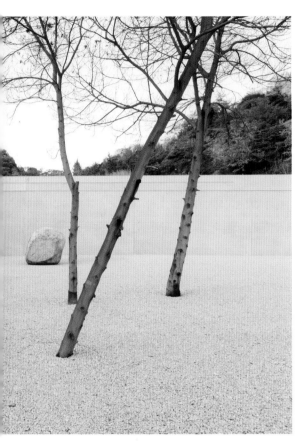

Name of Institution
Benesse Art Site Naoshima

Dates
Commenced 1989

Director
Benesse Art Site Naoshima, Inc.,
(managed by Benesse Holdings and
Naoshima Fukutake Art Museum
Foundation)

Soichiro Fukutake, *Director*

Location
1 Naoshima, Kagawa Prefecture, Japan
2 Inujima, Okayama Prefecture, Japan
3 Teshima, Kagawa Prefecture, Japan

Architects
Tadao Ando Architect & Associates
Tadao Ando
Osaka, Japan

Sambuichi Architects
Hiroshi Sambuichi
Hiroshima, Japan

Kazuyo Sejima and Associates
Kazuyo Sejima
Tokyo, Japan

Office of Ryue Nishizawa
Ryue Nishizawa
Tokyo, Japan

Other Active Architects
SANAA (Sejima and Nishizawa
and Associates)
Kazuyo Sejima and Ryue Nishizawa
Tokyo, Japan

Architects Atelier Ryo Abe
Ryo Abe
Tokyo, Japan

Naoshima

Notable Buildings
Benesse House Museum (1992)
Architect: Tadao Ando

Benesse House Oval (1995)
Architect: Tadao Ando

Chichu Art Museum (2004)
Architect: Tadao Ando
Artists: Walter De Maria, Claude
Monet, and James Turrell

Park and Beach (2006)
Architect: Tadao Ando

Lee Ufan Museum (2010)
Architect: Tadao Ando

Naoshima Bath "I♥Yu" (2009)
Artist: Shinro Ohtake

Art House Project

Kadoya (1998)
Artist: Tatsuo Miyajima

Kinza (2001)
Artist: Rei Naito

Haisha (2006)
Artist: Shinro Ohtake

Ishibashi (2006)
Artist: Hiroshi Senju

Gokaisho (2006)
Artist: Yoshihiro Suda

Go'o Shrine (2002)
Artist: Hiroshi Sugimoto

Minamidera (1999)
Architect: Tadao Ando
Artist: James Turrell

Selected Artists

Walter De Maria
Seen/Unseen Known/Unknown (2000),
Time/Timeless/No Time (2004)

Dan Graham
Cylinder Bisected by Plane (1995)

Cai Guo-Qiang
*Cultural Melting Bath: Project for
Naoshima* (1998)

Yayoi Kusama
Pumpkin (1994)

Hiroshi Sugimoto
Time Exposed Mirtoan Sea, Sounion
(1990), *Time Exposed S. Pacific Ocean,
Tearai* (1991)

James Turrell, *Backside of the Moon*
(1999), *Open Sky* (2004)

Naoshima Rice-Growing Project
www.komezukuri-project.com

Inujima

Notable Buildings
Inujima Art Project
Seirensho (2008)
Architect: Hiroshi Sambuichi
Artist: Yukinori Yanagi

Inujima Art House Project,
Phase 1 (2010):

F-Art House, S-Art House, I-Art House
Architect: Kazuyo Sejima
Artist: Yukinori Yanagi

Nakanotani Gazebo
Architect: Kazuyo Sejima

Teshima

Notable Building
Teshima Art Museum (2010)
Architect: Ryue Nishizawa
Artist: Rei Naito, *Matrix* (2010)

Selected Artists
Christian Boltanski
Les Archives du Cœur (2010)

Mariko Mori
Tom Na H-iu (2010)

Other Interventions
Tobias Rehberger
Il Vent (2010)

Shima Kitchen (2010)
Architect: Ryo Abe

↓ Top: Map of the islands of Naoshima,
Inujima, and Teshima in the Seto Inland Sea

Bottom: Historic photograph of Inujima's
copper refinery

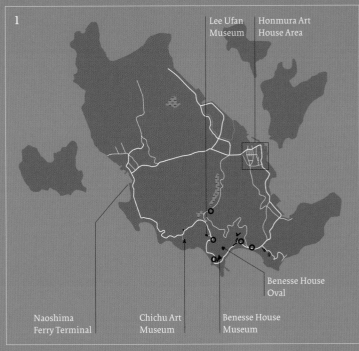

1

Lee Ufan
Museum

Honmura Art
House Area

Naoshima
Ferry Terminal

Chichu Art
Museum

Benesse House
Museum

Benesse House
Oval

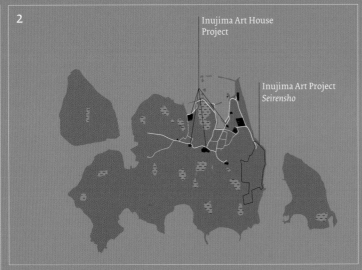

2

Inujima Art House
Project

Inujima Art Project
Seirensho

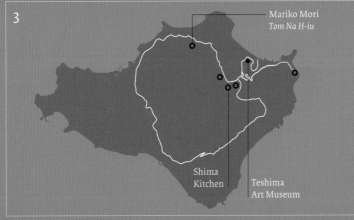

3

Mariko Mori
Tom Na H-iu

Shima
Kitchen

Teshima
Art Museum

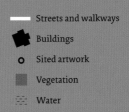

—— Streets and walkways

Buildings

○ Sited artwork

Vegetation

Water

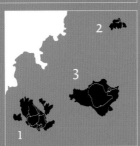

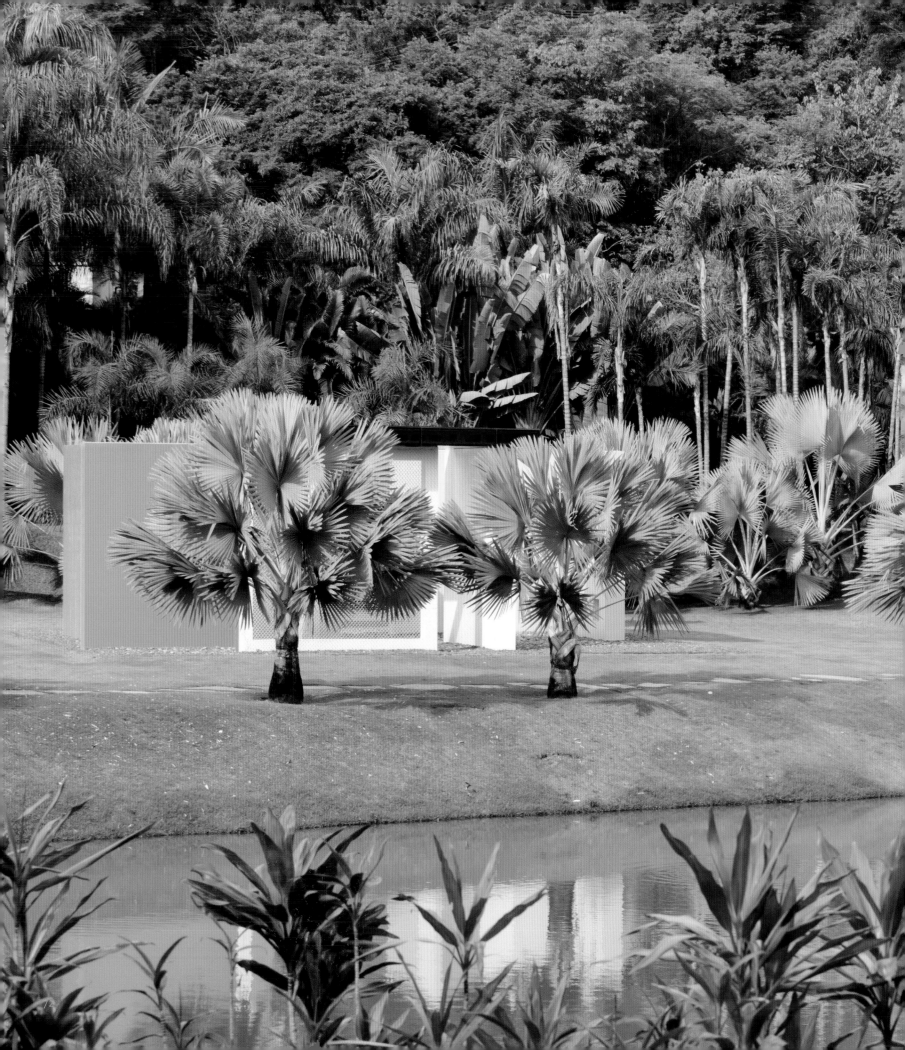

Instituto Inhotim
Brumadinho, Minas Gerais, Brazil

Instituto Inhotim, a seven-hundred-hectare nature reserve, began as a farmstead and family retreat. It is located south of Belo Horizonte, Brazil's third largest city and state capital of Minas Gerais. The brainchild of mining entrepreneur and art collector Bernardo Paz, Inhotim displays a growing collection of contemporary Brazilian and international art in "white cube" galleries, outdoors amid specimen plants, and, with increasing ambition, in specially designed pavilions. Inhotim also has a strong ecological agenda, seeking to preserve the indigenous Atlantic forest and the Brazilian savanna known as *cerrado*.

The name "Inhotim" is derived from "Mr. Tim," a British former owner of the farm. In the 1990s, forty hectares of the reserve were modified according to suggestions from Roberto Burle Marx (1909–1994), a key figure in Brazilian culture and one of the great landscape architects of the twentieth century. Today, the gardens at the heart of Inhotim communicate Burle Marx's belief that "a garden is a complex of esthetic and plastic intentions; the plant is, to a landscape artist, not only a plant—rare, unusual, ordinary or doomed to disappearance—but also a color, a shape, a volume, or an arabesque in itself."[1]

The park, which opened to the public in 2006, is centered on four serpentine lakes. As the institution expands its program to show in-situ art in this dramatic landscape, artists such as Chris Burden, Jorge Macchi, Matthew Barney, and Doug Aitken have begun to site work farther afield. In the near future, Inhotim may even construct hotel accommodation and conference facilities on the fringes of the extensive property.

The initial exhibition galleries, designed by Belo Horizonte architect Paulo Orsini, are comparatively orthodox structures. They are known as Fonte (Fountain), Lago (Lake), Mata (Forest), and Praça (Place or Square). One highlight of the collection is Cildo Meireles's *Através* (1983), an installation that invites visitors to walk across shards of broken glass and move between screens made from industrial materials. To the end of one lake, a stark white pavilion amid verdant planting contains *True Rouge*, a vividly red installation from 1997 by Tunga, another key contemporary Brazilian artist and an advisor to Paz in the early days of Inhotim.

Among the permanent pavilions is one by Rio-based artist Adriana Varejão designed with the young São Paulo architect Rodrigo Cerviño Lopez. The boxlike gallery hovers out above a square pool. Visitors traverse this pool to a skewed island; then turn toward an entrance beneath the cantilevered soffit. Inside, they encounter trompe l'oeil works by Varejão that incorporate the imagery of traditional tiles called *azulejos*. Upstairs, within the box, visitors are surrounded by 184 large blue-and-white *azulejos* that comprise *Celacanto Provoca Maremoto* (2004–2008). They ascend again to exit onto a roof terrace where benches are tiled with images of birds typical of the region (*Passarinho–de Inhotim a Demini*, 2008).

This sense of promenade and of exploration between nature and design is characteristic of Inhotim. Thai artist Rirkrit Tiravanija—whose *Palm Pavilion* (2006–2008) is an adaptation of French architect Jean Prouvé's Maison Tropicale (1951)—has stated that this landscape "gives you time to think about what you've just looked at as you walk from place to place."[2]

Arquitetos Associados, a young firm based in Belo Horizonte, has designed many of the recent structures. For Colombian artist Doris Salcedo's installation *Neither* (2004), the exact interior proportions of White Cube gallery in London, where the work was originally shown, was replicated. Walls are textured with wire mesh that emerges from, and recedes into, the white planar walls of the gallery, creating an unsettling experience in this iconic art setting. The London gallery was inspired in its choice of name by Brian O'Doherty's critique from the 1970s.

Arquitetos Associados have subsequently designed the Cosmococas Gallery specifically for Hélio Oiticica and Neville D'Almeida's five *Cosmococas* (1973). This single-story stone structure has several entrances and a labyrinth-like plan. A grass roof allows it to blend with the surrounding landscape. A similar strategy by the same architects is evident in the large gallery and restaurant currently under construction. Conversely, their pavilion for artist Miguel Rio Branco emerges in stark contrast to its site as a metal-clad erratic.

The extent of the property at Inhotim has allowed its curators to commission works that could not be realized at most other institutions. Chris Burden's *Beam Drop Inhotim* (2008) requires an unobstructed site; for the potentially dangerous process of creating this work, a team and expensive equipment were needed to drop structural beams from a height of forty-five meters. At Doug Aitken's *Sonic Pavilion* (2009), geological microphones enable visitors listen to otherwise imperceptible sounds deep under the earth's surface.

A key component of Inhotim is the preservation of the environment and the education of local youth. The botanical collection, for example, contains over 1,500 species of palm trees. Each year, thousands of students and teachers participate in interdisciplinary programs that explore issues related to art, botany and local culture. The institution has also partnered with the public school in Brumadinho, the neighboring town, to create "Inhotim Laboratory." Adolescents develop skills in various art forms, as well as knowledge of curatorial practices and art criticism.

Parallel programming focuses on biodiversity and enables students to develop practical knowledge about the environment and agricultural practices. Many young participants contribute to the evolution of educational programs.

Designed by Arquitetos Associados to meet Inhotim's ambitious educational program, the Burle Marx Education Center has a roof garden with shapes reminiscent of those found in Burle Marx's plans. These geometric forms composed of lightly colored tiles are contrasted against purple and green plant life in a body of water. *Narcissus Garden Inhotim* (2009) is a work by Japanese artist Yayoi Kusama consisting of five hundred stainless steel spheres; it provides silvery accents that float across the water and complement the dynamism of the roof garden.

In 2010, Rizoma Arquitetura, a second young practice based in Belo Horizonte, realized two further buildings at Inhotim: a lakeside restaurant close to a multicolored planar pavilion by the late Brazilian artist Hélio Oiticica and a store for plants and botanical specimens.

Ultimately, Inhotim is an act of faith in Brazil's future. "Children can't learn between four walls," Paz has been quoted as saying. "Sometimes museums only want to buy very intellectual pieces of art but people want to see things that spur their curiosity and interact with everything."[3]

→ View of the park at Inhotim, with Hélio Oiticica's *Invenção da cor, Penetrável Magic Square #5, De Luxe* and Rizoma Arquitetura's Oiticica Restaurant

1 Roberto Burle Marx, paper presented at the 55th annual meeting of the American Society of Landscape Architects, Boston, June 28–30, 1954.
2 Rirkrit Tiravanija, quoted in "Where Dreams Come True," *Art Newspaper* 218 (November 2010), http://www.theartnewspaper.com/articles/where-dreams-come-true/21858.
3 Bernando Paz, quoted in ibid.

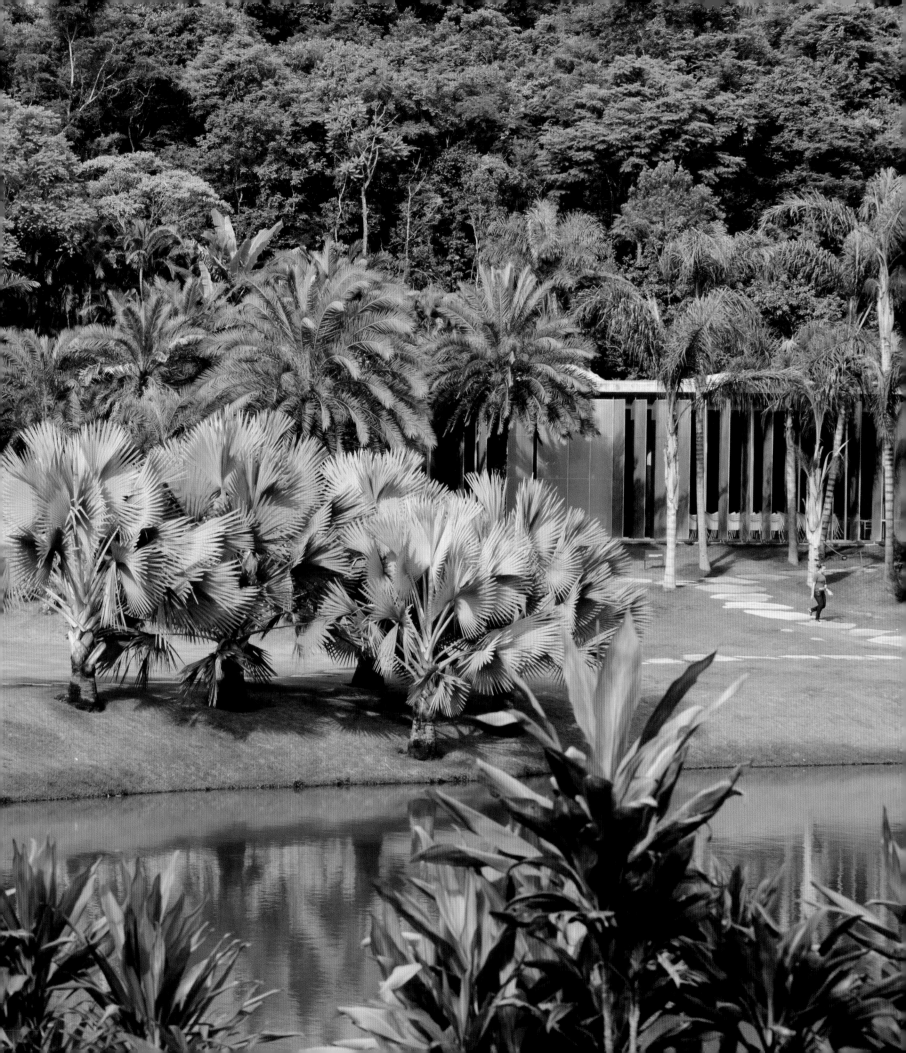

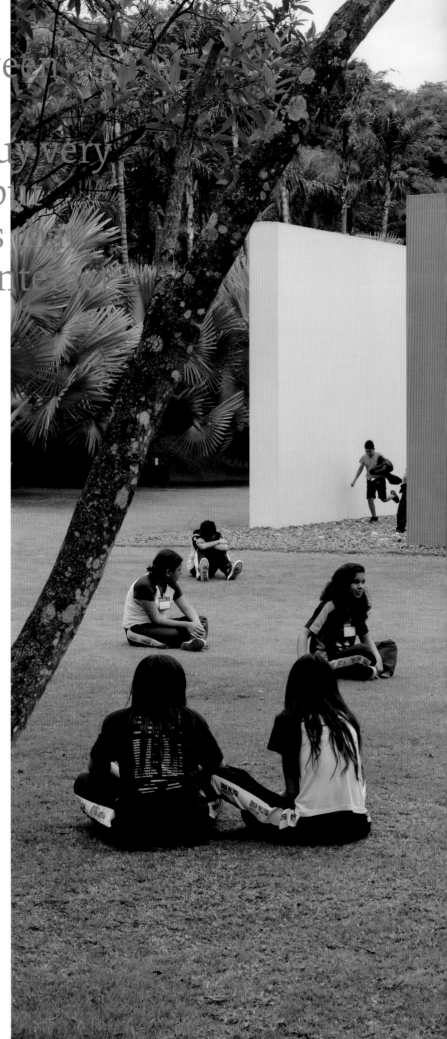

Children can't learn between four walls. Sometimes museums only want to buy very intellectual pieces of art but people want to see things and spur their curiosity and interact with everything.

Bernardo Paz, *Art Collector and Founder*

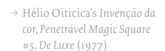

→ Hélio Oiticica's *Invenção da cor, Penetrável Magic Square #5, De Luxe* (1977)

→→ Overleaf: View of pavilion at Inhotim housing *True Rouge* by Tunga (1997)

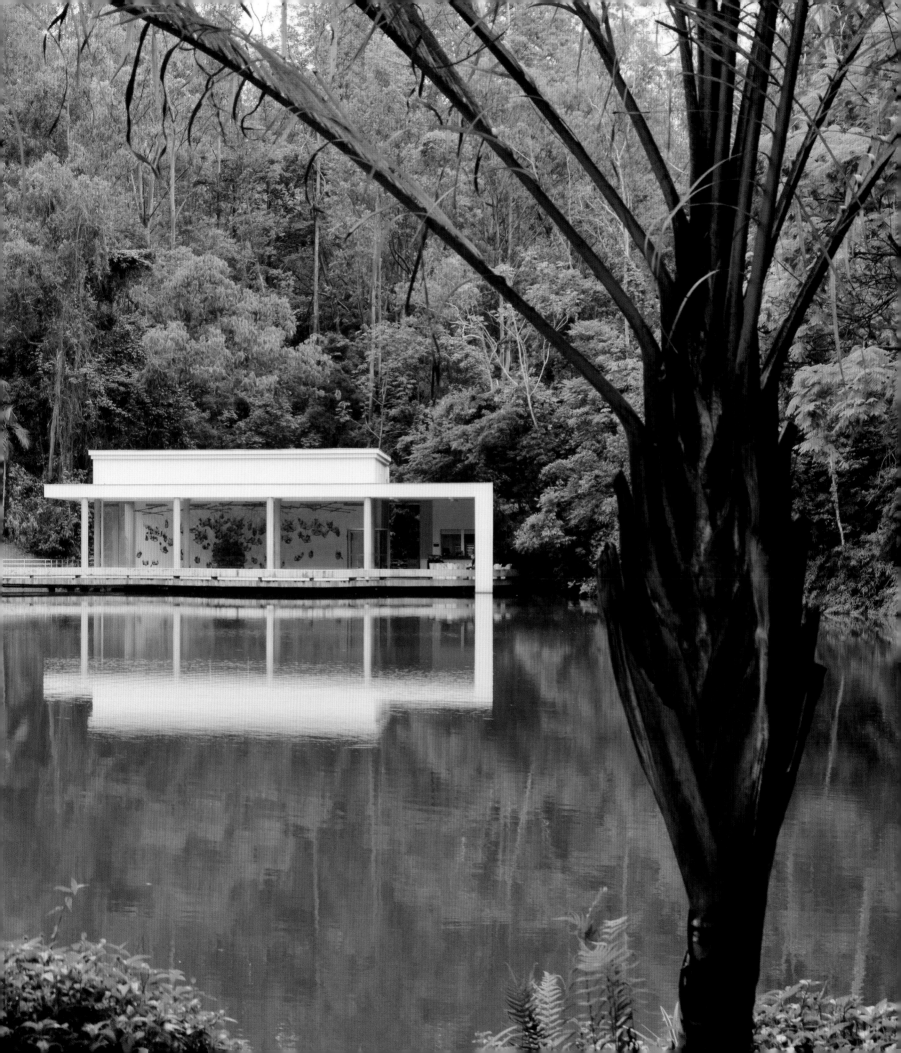

↑ Left: Interior of Cildo Meireles's *Através* (1983–1989), where visitors traverse a field of glass shards amid hanging screens

Right: Miguel Rio Branco Gallery terrace with steps leading to upper gallery space

→ Left: Interior of Matthew Barney's installation *De Lama Lâmina* (2004/2009)

Right: Chris Burden's *Beam Drop Inhotim* (2008)

→→ Overleaf: Interior of Doug Aitken's *Sonic Pavilion* (2009)

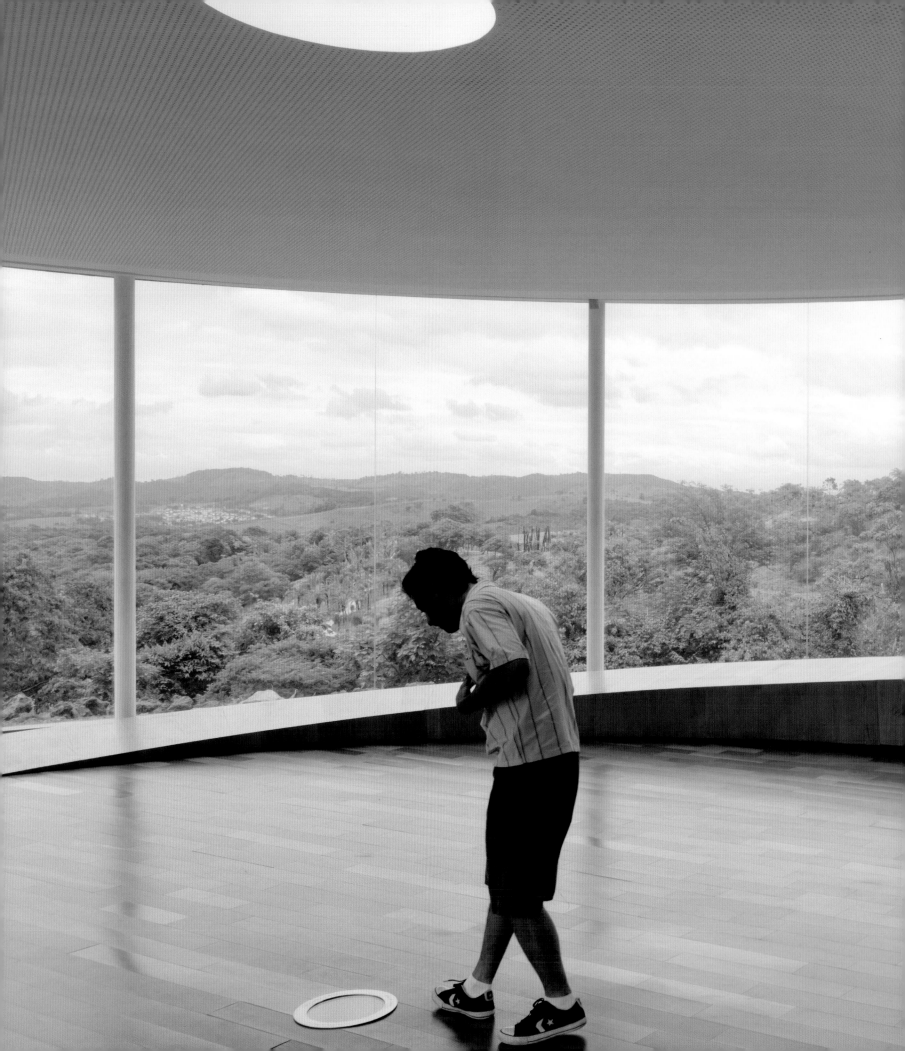

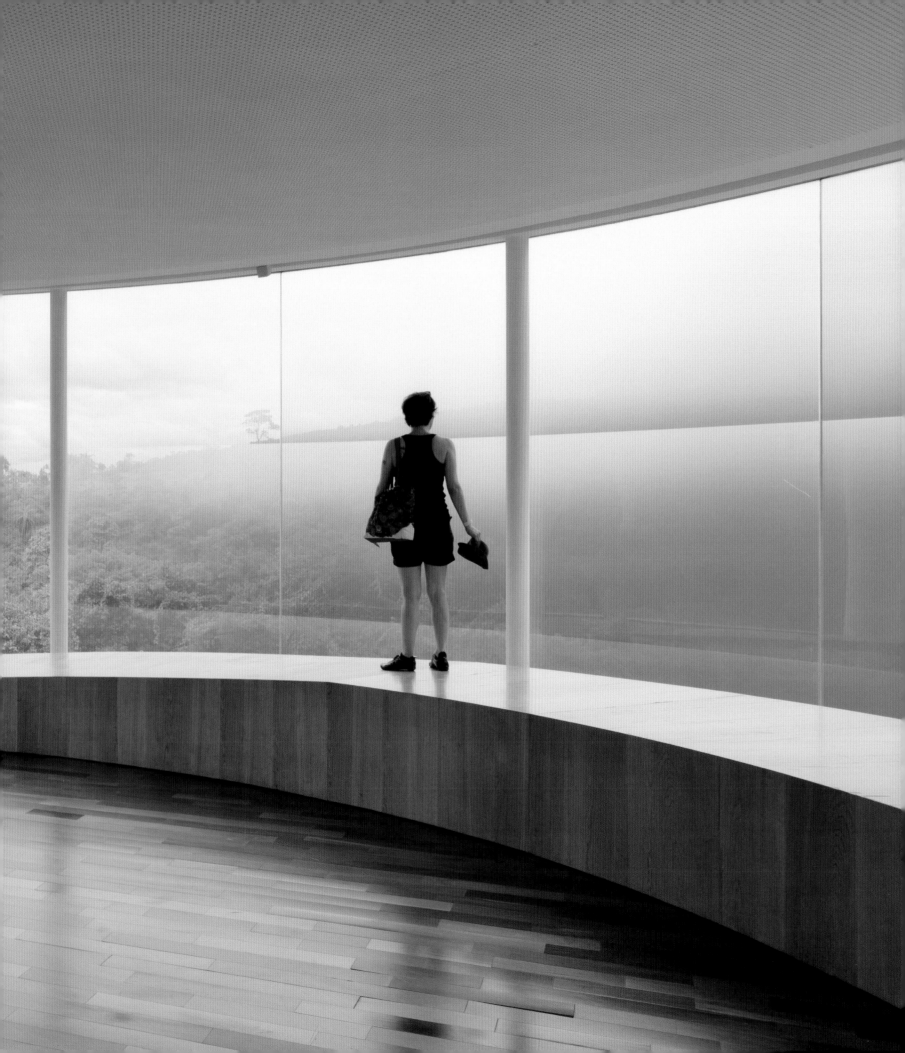

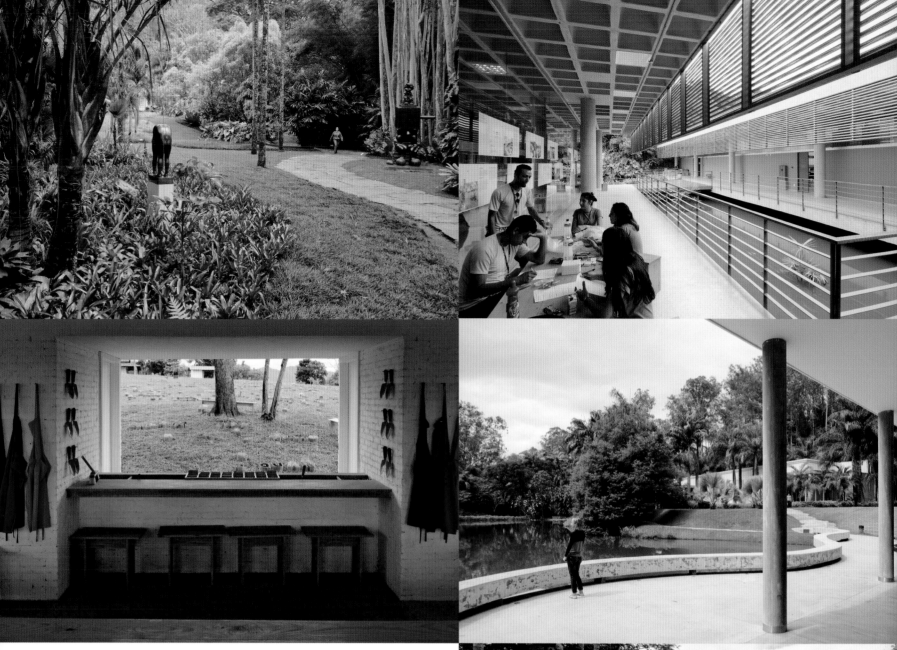

↑↑ Left to right: Park at Inhotim with features characteristic of Roberto Burle Marx's landscape works

Interior courtyard of Burle Marx Educational Center

Rooftop garden on Burle Marx Educational Center with Yayoi Kusama's installation *Narcissus Garden Inhotim* (2009)

Outdoor gathering area adjacent to Burle Marx Educational Center

↑ Left to right: Interior of Marilá Dardot's *A Origem da Obra de Arte* pavilion (2002), where participants plant seeds in letter-shaped planters that form messages

View from *True Rouge* pavilion, echoing Brazilian Modernist influences

Exterior of Adriana Varejão Gallery with reflecting pool and tiled bench

Ground floor of Adriana Varejão Gallery showing installation *Linda do Rosário* (2004–2008)

→ Left to right: Exterior of Rirkrit Tiravanija's *Palm Pavilion* (2006–2008)

Exterior of Botanical Store by Rizoma Arquitetura

Interior of Doris Salcedo's installation *Neither* (2004), originally exhibited at White Cube, Hoxton Square, London

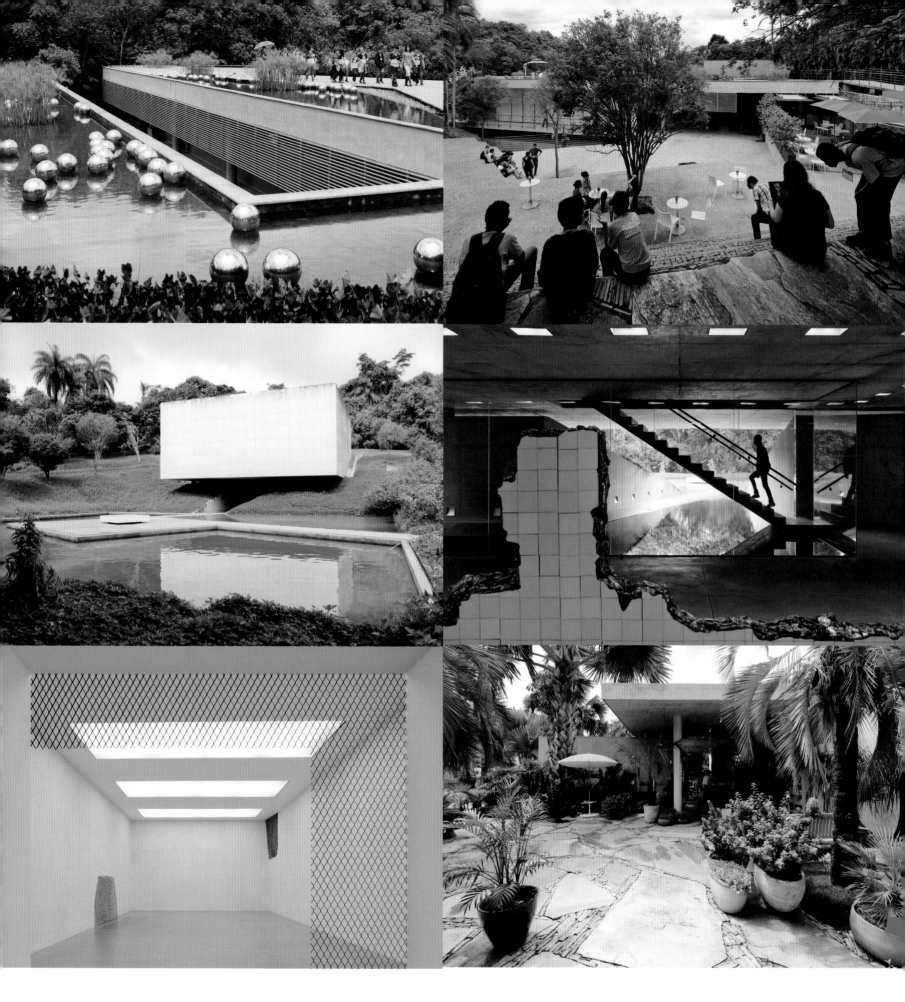

Name of Institution
Instituto Inhotim

Area
Botanical garden with art installations: 97 hectares (239.7 acres)
Nature reserve: 600 + hectares (1,483 acres)

Dates
Founded 2004
Opened 2006

Founder
Bernardo Paz

Directors and Curators
Roseni Sena, *Executive Director and Inclusion and Citizenship Director*

Jochen Volz, *Artistic Director*

Allan Schwartzman, *Chief Curator*

Rodrigo Moura, *Curator*

Joaquim de Araíyo Silva, *Botanical Garden Director*

Marco Otávio Pivari, *Botanical Curator*

Location
Brumadinho, Minas Gerais, Brazil

Architects
Arquitetos Associados
Alexandre Brasil, André Luiz Prado, Bruno Santa Cecília, Carlos Alberto Maciel, Paula Zasnicoff Cardoso
Belo Horizonte, Brazil

Rodrigo Cerviño Lopez
São Paulo, Brazil

Rizoma Arquitetura
Maria Paz, Thomaz Regatos, Marcos Franchini
Belo Horizonte, Brazil

Landscape Architects
Roberto Burle Marx (guidelines only)

Pedro Nehring

Luiz Carlos Orsini

Notable Buildings
Adriana Varejão Gallery (2008)
Architect: Rodrigo Cerviño Lopez

Burle Marx Educational Center (2006)
Architect: Arquitetos Associados
Artist: Yayoi Kusama

Miguel Rio Branco Gallery (2008)
Architect: Arquitetos Associados

Cosmococas Gallery (2008)
Architect: Arquitetos Associados
Artists: Hélio Oiticica and Neville D'Almeida

Doris Salcedo Gallery (2008)
Architect: Arquitetos Associados; Paula Zasnicoff Cardoso with the Salcedo studio

Oiticica Restaurant (2010)
Architect: Rizoma Arquitetura

Entrance Pavilion (2012)
Architect: Rizoma Arquitetura

Botanical Store (2011)
Architect: Rizoma Arquitetura

Selected Artists
Doug Aitken
Sonic Pavilion (2009)

Matthew Barney
De Lama Lâmina (2004/2009)

Chris Burden
Beam Drop Inhotim (2008), *Beehive Bunker* (2009)

Janet Cardiff & George Bures Miller
The Murder of Crows (2008)

Marilá Dardot
A Origem da Obra de Arte (2002)

Edgard de Souza
Untitled (1998), *Untitled* (2001), *Untitled* (2000, 2002, 2005)

Olafur Eliasson
Viewing Machine (2001–2008), *By Means of a sudden intuitive realization* (1996)

Dominique Gonzalez-Foerster
Desert Park (2010)

Dan Graham
Bisected Triangle, Interior Curve (2002)

Yayoi Kusama
Narcissus Garden Inhotim (2009)

Jarbas Lopes
Troca-Troca (2002)

Jorge Macchi
Piscina (2009)

Paul McCarthy
Boxhead (2001)

Cildo Meireles
Através (1983–1989), *Desvio para o vermelho, I: Impregnação, II: Entorno, III: Desvio* (1967–1984)

Vik Muniz
The Sarzedo Drawings (2002)

Ernesto Neto
Nave Deusa (1998)

Rivane Neuenschwander
Continent/Cloud (2008)

Hélio Oiticica
Invenção da cor, Penetrável Magic Square #5, De Luxe (1977)

Hélio Oiticica and Neville D'Almeida
CC1 - Trashiscapes, CC2 - Onobject, CC3 - Maileryn, CC4 - Nogacions, and CC5 - Hendrix War (1973)

Miguel Rio Branco
Photographs and photographic installations in Miguel Rio Branco Gallery include *Diálogos com Amaú* (1983) and *Entre os olhos o deserto* (1997)

Pipilotti Rist
Homo Sapiens Sapiens (2005)

Doris Salcedo
Neither (2004)

Valeska Soares
Folly (2005–2009)

Simon Starling
The Mahogany Pavilion (Mobile Architecture No. 1) (2004)

Rirkrit Tiravanija
Palm Pavilion (2006–2008)

Tunga
True Rouge (1997)

Adriana Varejão
Celacanto Provoca Maremoto, Linda do Rosário, Carnívoras, and *O Colecionador* (2004–2008)

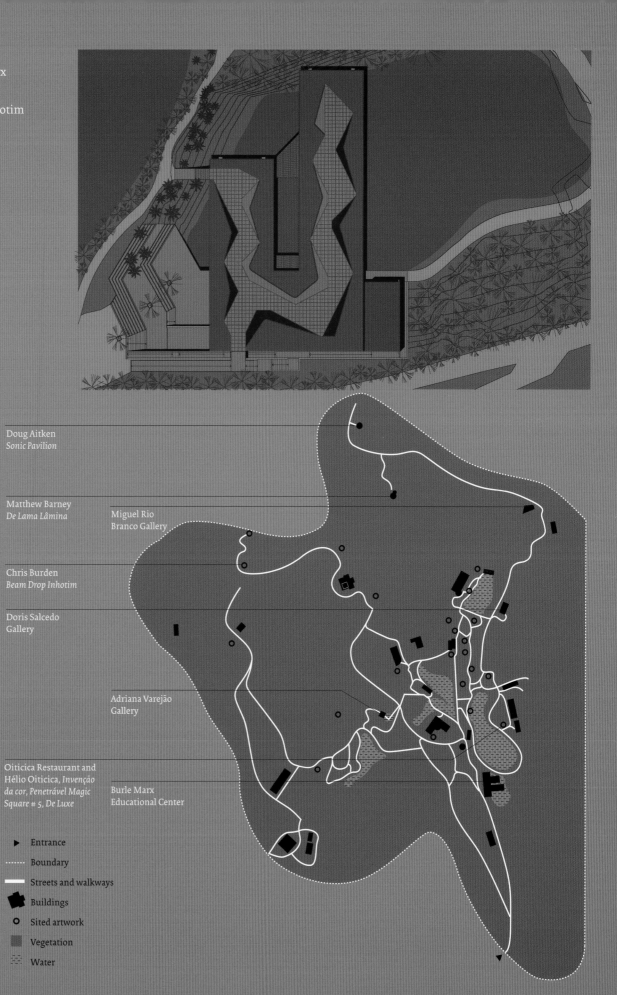

→ Top: Plan by Arquitetos
Associados of Burle Marx
Educational Building

Bottom: Site plan of Inhotim

↙ Historic photograph of
original farmhouse at
Inhotim c. 1980

Doug Aitken
Sonic Pavilion

Matthew Barney
De Lama Lâmina

Miguel Rio
Branco Gallery

Chris Burden
Beam Drop Inhotim

Doris Salcedo
Gallery

Adriana Varejão
Gallery

Oiticica Restaurant and
Hélio Oiticica, *Invenção
da cor, Penetrável Magic
Square # 5, De Luxe*

Burle Marx
Educational Center

▶ Entrance

∙∙∙∙∙ Boundary

▬▬ Streets and walkways

◼ Buildings

○ Sited artwork

 Vegetation

 Water

Culiacán is the capital of Sinaloa, a state with a very warm, semi-arid climate in northwest Mexico. The city's botanical garden is currently being redefined to conserve and propagate local and exotic species and to accommodate contemporary works of art. The plants and the specially commissioned art are dispersed amid informal clusters of pavilions. The patrons for this multilayered project are Agustín and Isabel Coppel, department store owners and art collectors based in Culiacán.

Interviewed for *Mexico: Expected/Unexpected*, an exhibition of their collection in 2011, Agustín Coppel noted that "Today, more than ever, Mexican artists are very successful when they get involved at an international level, they have a Mexican fiber, they are not obviously folkloric, but they are Mexican in a deeper way. I believe this is very valuable for Mexico...that there is a message of globalization in these new artists. And the same is happening in architecture, in film."[1]

The botanical garden was established for study and leisure in 1986 by a local engineer, Carlos Murillo Depraect. Since then, it has displayed and conserved plant species from around the world and, more specifically, northern Mexico. Like Inhotim in Brazil, the Jardín Botánico emphasizes ecology alongside innovative art. In this desert habitat, the long-established garden is being revitalized by removing or thinning out overgrowth and by clarifying zones allocated to specific plant types.

Exploring the gardens, visitors discover sculptural interventions, many of architectural scale, by established international figures such as James Turrell and Dan Graham as well as emerging Mexican artists. Architectural interventions consist of discrete pavilions, typically small monoliths of exposed in-situ concrete. Designed by the architect Tatiana Bilbao, these small buildings—a lecture hall, a library, a café—defer to the garden layout.

Bilbao previously built a remarkable seaside home with the artist Gabriel Orozco. More recently, she and Mexico City architect Derek Dellekamp, together with colleagues including Ai Weiwei (China), Elemental (Chile), and HHF architects (Switzerland), have built a chain of small structures along a pilgrimage route in the state of Jalisco.

For the Jardín Botánico, Bilbao is collaborating with TOA, Taller de Operaciones Ambientales, a landscape design firm led by Lara Becerra, Emiliano García, and Juan Rovalo. This multidisciplinary team takes a holistic approach to the development of ecologically sustainable plans. Although Bilbao is also constructing a dramatic biotechnology building for the university in Culiacán, both she and TOA are based in Mexico City.

The plan for the garden—a network of new paths woven into the existing grain—was inspired by patterns created by sunlight and tree branches. These pathways divide the park into botanical zones that include a bamboo glade, a tropical rainforest, a food forest, xeriscape, and a palm garden. The routes lead visitors to pavilions and art installations located throughout the park. Bodies of water are integrated into the plan for irrigation and cooling purposes. The dynamic and organic shadows created by the plants and tree canopies are an important aesthetic component of the landscape.

Bilbao's concrete pavilions are typically clustered in groups of two or three situated on the periphery of communal paths. Impossibly thin walls cant or tilt to lessen their physical impact and catch both dappled light and the shadows of foliage above.

Visitor facilities—including a café, lecture hall, and library—are located near the entrance in the park's southwest corner. Additional educational facilities are situated near the center of the park, between the palm garden and orchard, and host video works by Tacita Dean and Fernando Ortega. A linear building for storage and laboratories is planned for the northern edge of the site. An *invernadero*, or shaded greenhouse, will occupy a pond of water between the spice and exotic fruit gardens; it will contain installations by Corey McCorkle and Mario García Torres.

Interventions complementing the natural surroundings are placed at major nodes throughout the park. Olafur Eliasson has contributed a five-legged arbor for ficus plants with an open oculus at its center. Sofía Táboas has built a pavilion with a canopy of colored glass disks. Abraham Cruzvillegas proposes an open frame structure that expands according to the Fibonacci series. The Swiss practice Herzog & de Meuron is designing a plaza with many small fountains.

Among the Mexican or Mexico-based artists represented in the garden are Gabriel Orozco, Francis Alÿs, Pedro Reyes, Marco Rountree, Teresa Margolles, and the collective Tercerunquinto. Both Alÿs and Reyes trained initially as architects. Reyes's project responds to Culiacán's grim murder statistics—he crushed guns captured by the police from local gangs, turning them into shovels to be given to schools and community groups in order to plant trees. Culiacán native Margolles has made Modernistic chaises longues with cement mixed using water collected from city morgues.

Major installations by James Turrell and by Jorge Pardo are still in the planning stage. Turrell's *Observatory* will be the largest architectural feature in the park. Visitors will enter via pathways that ascend to a bridge where a large glass enclosure will provide a new perspective on the surrounding gardens. Pardo's *Desert* is an octagonal enclosure with high walls. It has four entry points that will lead visitors through tunnels to emerge into a highly gradated topography no longer shaded by the verdant growth of the garden.

A tower by Rirkrit Tiravanija is envisaged to overlook the gardens from the east. This structure will consist of a metal framework and an industrial elevator that ascends almost fifty feet to a viewing platform. From there, visitors will be able to view the remodeled park with its canopy of mature trees, water elements, and occasional glimpses of buildings.

The Jardín Botánico de Culiacán allows citizens and tourists alike to enjoy a remarkable collection of plants, to linger in the shade and follow newly inserted waterways (the water is recycled) as well as be exposed to art by leading contemporary artists. Bilbao's architecture is careful not be overtly rhetorical. The project's primary intent is to establish a rapport with visitors.

According to Agustín Coppel, "each of the visitors...will have an unexpected contact with contemporary art...This will open their minds and generate interest." To which Isabel Coppel responds: "But that has always been your interest—promoting a taste for art, so there is a change in the way people think...to see how that change and that flexibility that comes from art applies to their lives."[2]

1 Augustín Coppel, quoted in *Mexico: Expected/Unexpected*, ed. Idurre Alonso, Susan Golden, and Martha Guzmán (Long Beach: Museum of Latin American Art; La Jolla: Museum of Contemporary Art San Diego, 2011), 23.
2 Ibid., 26.

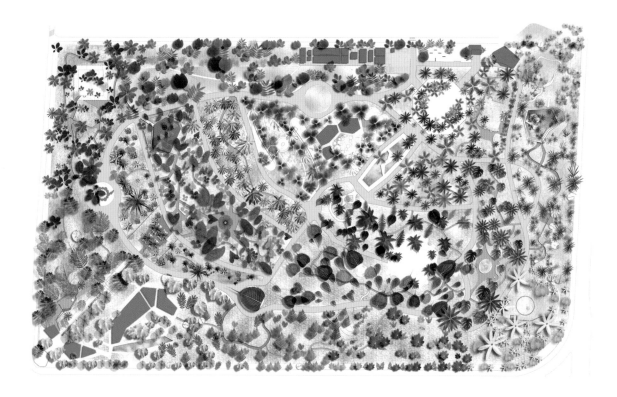

Each of the visitors to the Botanical Garden will enter the experience of the garden itself with its natural charms, and will have an unexpected contact with contemporary art...This will open their minds and generate interest.

Agustín Coppel, *Art Collector and Patron*

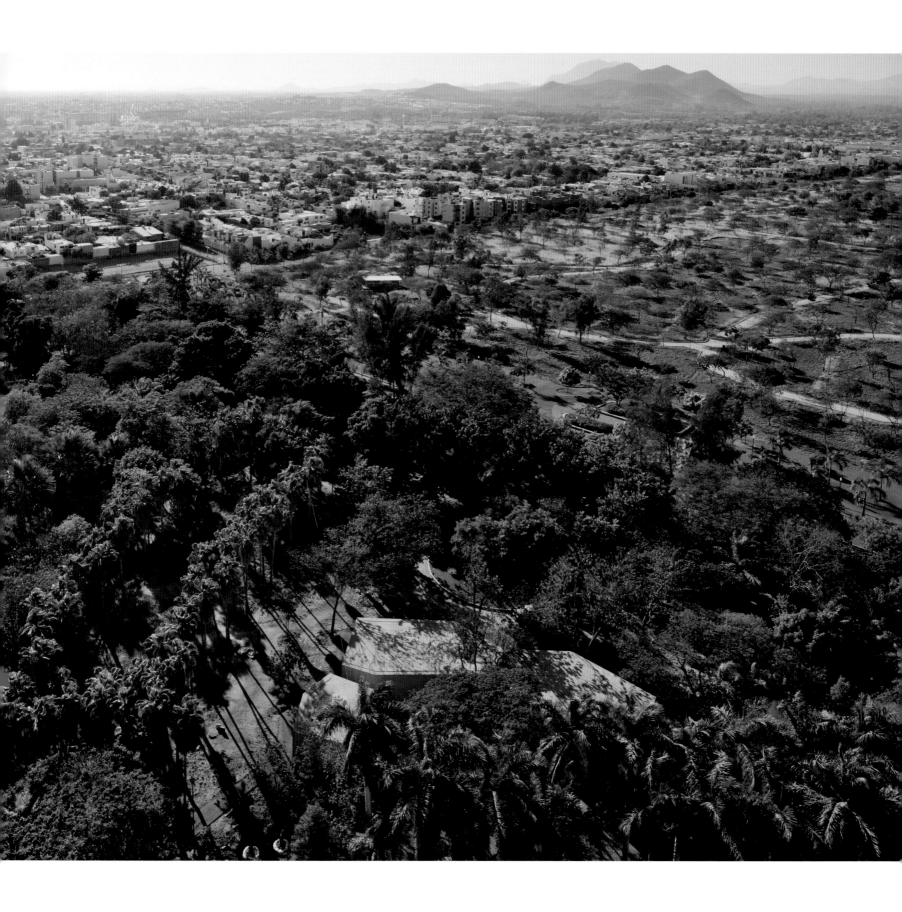

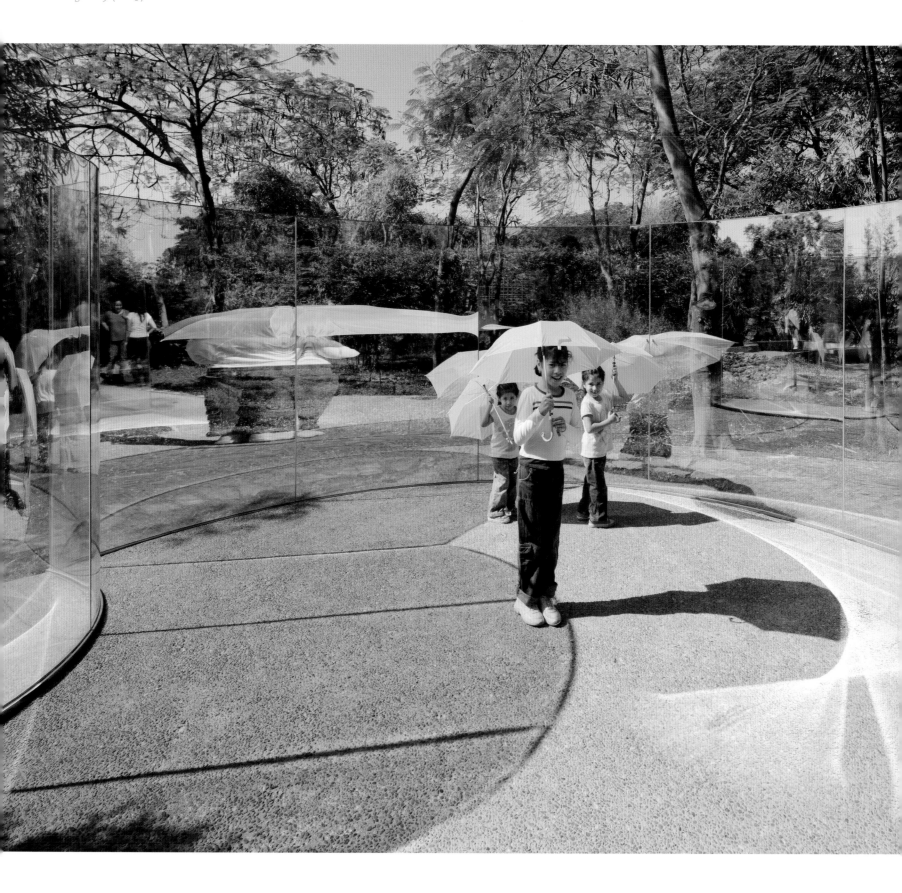

↓ Dan Graham's *Concave/Convex,*
Hedge Folly (2005)

↓ Top: View of patterns of shade and colored light produced by Sofía Táboas's *Plataforma elevada con plan extraterrestre* (2008–2011)

Bottom: Teresa Margolles's *Untitled* (2006) with concrete chaises longues made with water collected from city morgues

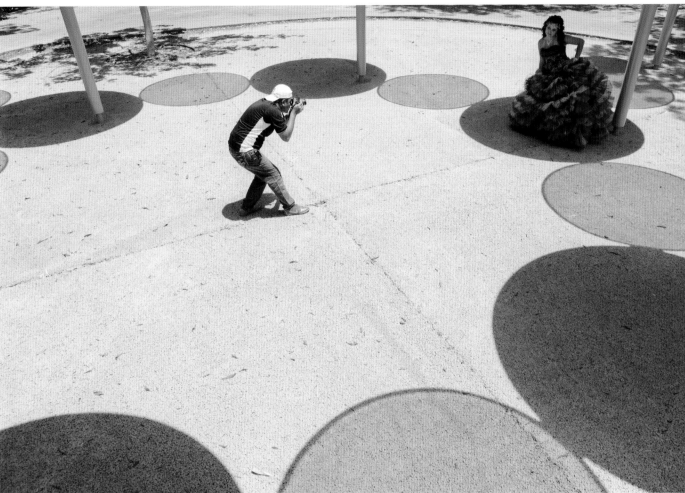

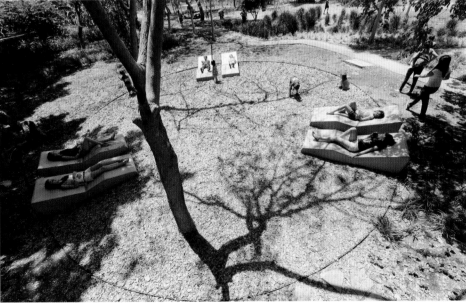

→→ Overleaf: View through Olafur Eliasson's *The Flower Archway*, (2005) a pavilion that supports five varieties of climbing vines

↓ Top: Exterior of Educational and
Multipurpose Building by Tatiana Bilbao

↘ Lily ponds with Educational and
Multipurpose Building in the background

Bottom: Small outdoor amphitheater by
Tatiana Bilbao

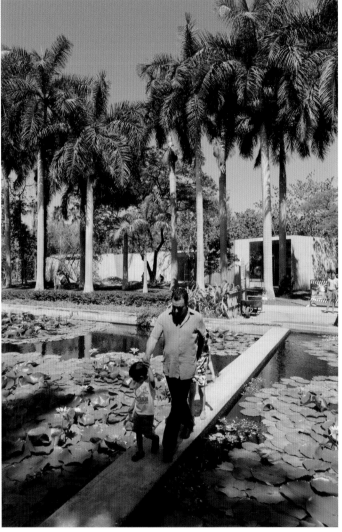

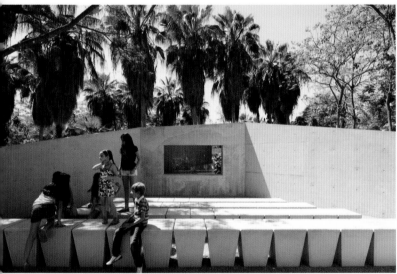

↓ Botanical landscape with improved
waterways and bamboo garden

↓ View through Educational and
Multipurpose Building

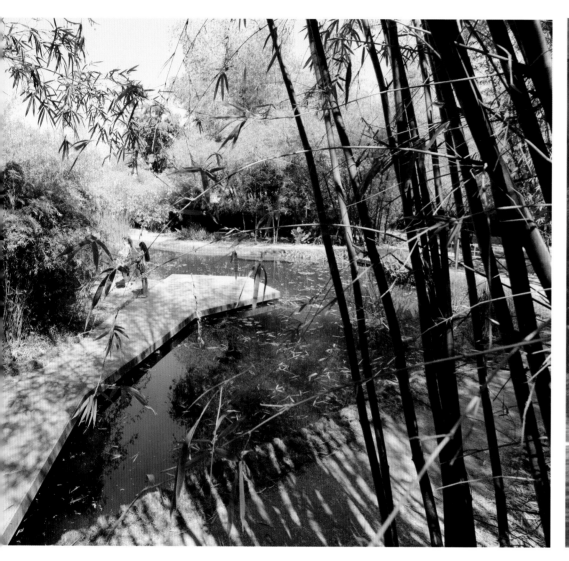

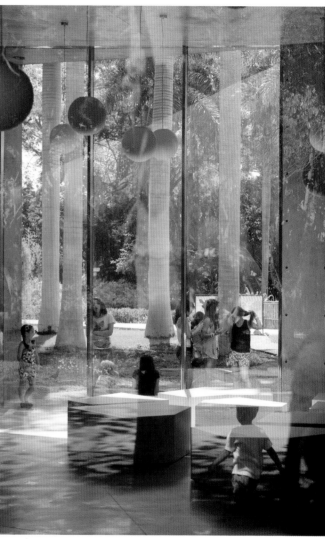

→→ Overleaf: Interior of Educational and Multipurpose
Building with lofted storage and learning spaces

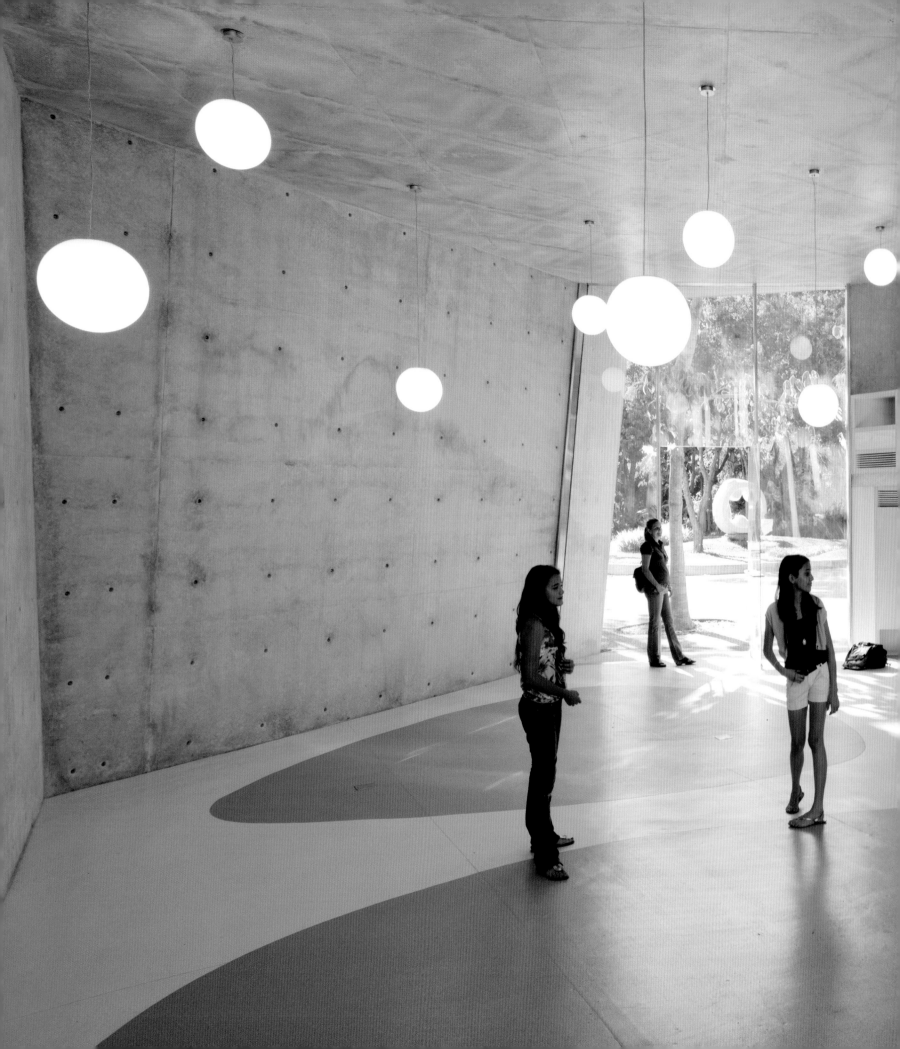

Name of Institution
Jardín Botánico de Culiacán

Area
10.9 hectares (27 acres)

Dates
Phase 1 of construction, 2007–2010
Phase 2 of construction, 2009–2011
Phase 3 of construction, 2012–2016

Client
Sociedad Botánica y Zoologica
de Sinaloa IAP

Carlos Murillo Michel, *Director*

Coppel Collection
(Colección Isabel y Agustín Coppel)

Mireya Escalante, *Director*

Location
Culiacán, Sinaloa, Mexico

Art Program/Curator
Patrick Charpenel

Architect
Tatiana Bilbao, S.C.
Tatiana Bilbao
Mexico City, Mexico

Landscape Architects
TOA, Taller de Operaciones
Ambientales
Lara Becerra, Emiliano García,
Juan Rovalo
Mexico City, Mexico

Notable Buildings
—All by Tatiana Bilbao

Educational and Multipurpose
Building (2011)

Auditorium (2011)

Exhibition Room

Pottery Workshop

Library

Service Areas

Office and Cafeteria with Store

Invernadero
Artist: Corey McCorkle

Storage and Laboratory Building

Selected Artists
Allora & Calzadilla
Untitled (2008)

Francis Alÿs
Game Over (2011)

Abraham Cruzvillegas
Sin Fin (proposed)

Tacita Dean
Clovers (2010)

Marcel Dzama
Muñeca de Nieve (2011)

Olafur Eliasson
The Flower Archway (2005)

Mario García Torres
Cannibis Sativa (ongoing)

Dan Graham
Concave/Convex, Hedge Folly (2005)

Herzog & de Meuron

Richard Long
White Quarz Ellipse (2000)

Teresa Margolles
Untitled (2006)

Corey McCorkle
Bindu Dome (proposed)

Rivane Neuenschwander
Nestor O Destatuador (Zé Carioca No. 13)
(2003)

Roman Ondak

Julian Opie
My Aunt's Sheep (1997)

Gabriel Orozco
Go 4 No Borders (2006)

Fernando Ortega
Finale (2009–2010)

Kiyoto Ota Okusawa
Círculo Blanco (2003)

Jorge Pardo

Marcos Ramírez Erre
Cruce de Caminos (2003)

Pedro Reyes
Palas por Pistolas (ongoing)

Marco Rountree
Untitled (2011)

Anri Sala
*Botanical Garden (Red, purple, blue,
white, green)* (2008)

Tino Sehgal

Melanie Smith

Valeska Soares
Caprichos (2004)

Simon Starling
Mossed Moore (2009–2011)

Sofía Táboas
*Plataforma elevada con plan
extraterrestre* (2008–2011)

Tercerunquinto
Ruinas/Nueva Arquitectura (2011)

Diana Thater
Flores Rojas (2001)

Rirkrit Tiravanija

Torolab

James Turrell
Skyspace (proposed project)

Atelier Van Lieshout
Watertree (proposed sculpture)

Pablo Vargas Lugo
Estrella rota (2007)

Franz West

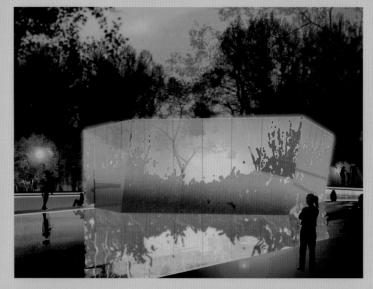

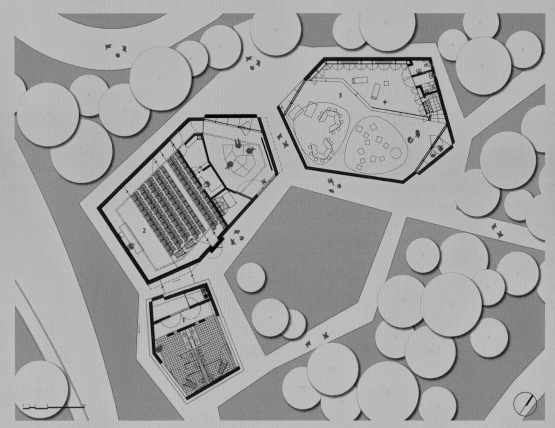

→ Top: Plan by Tatiana Bilbao of Educational and Multipurpose Building

Bottom: Site plan of Jardín Botánico de Culiacán

↙ Left: Exterior rendering of the *invernadero*, a shaded greenhouse for plants needing protection from direct sunlight

Right: Photograph of light and shadow through trees that served as inspiration for Culiacán project, taken by Tatiana Bilbao

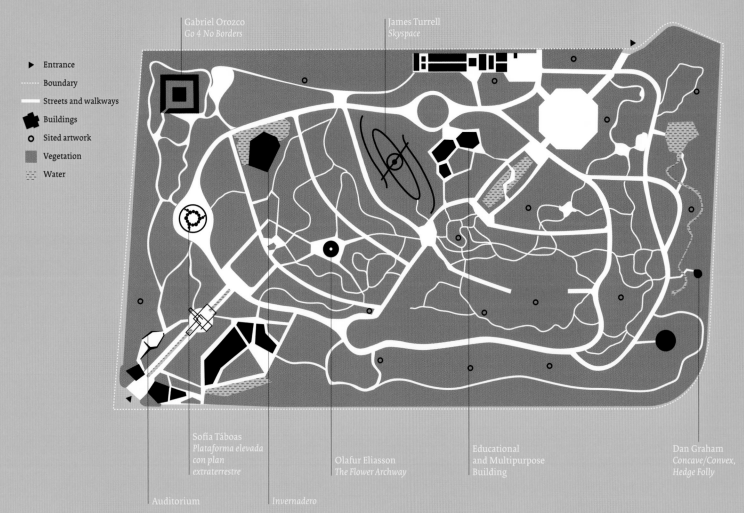

Gabriel Orozco
Go 4 No Borders

James Turrell
Skyspace

▶ Entrance
⋯⋯ Boundary
━━ Streets and walkways
◼ Buildings
○ Sited artwork
▨ Vegetation
▦ Water

Sofia Táboas
Plataforma elevada con plan extraterrestre

Olafur Eliasson
The Flower Archway

Educational and Multipurpose Building

Dan Graham
Concave/Convex, Hedge Folly

Auditorium

Invernadero

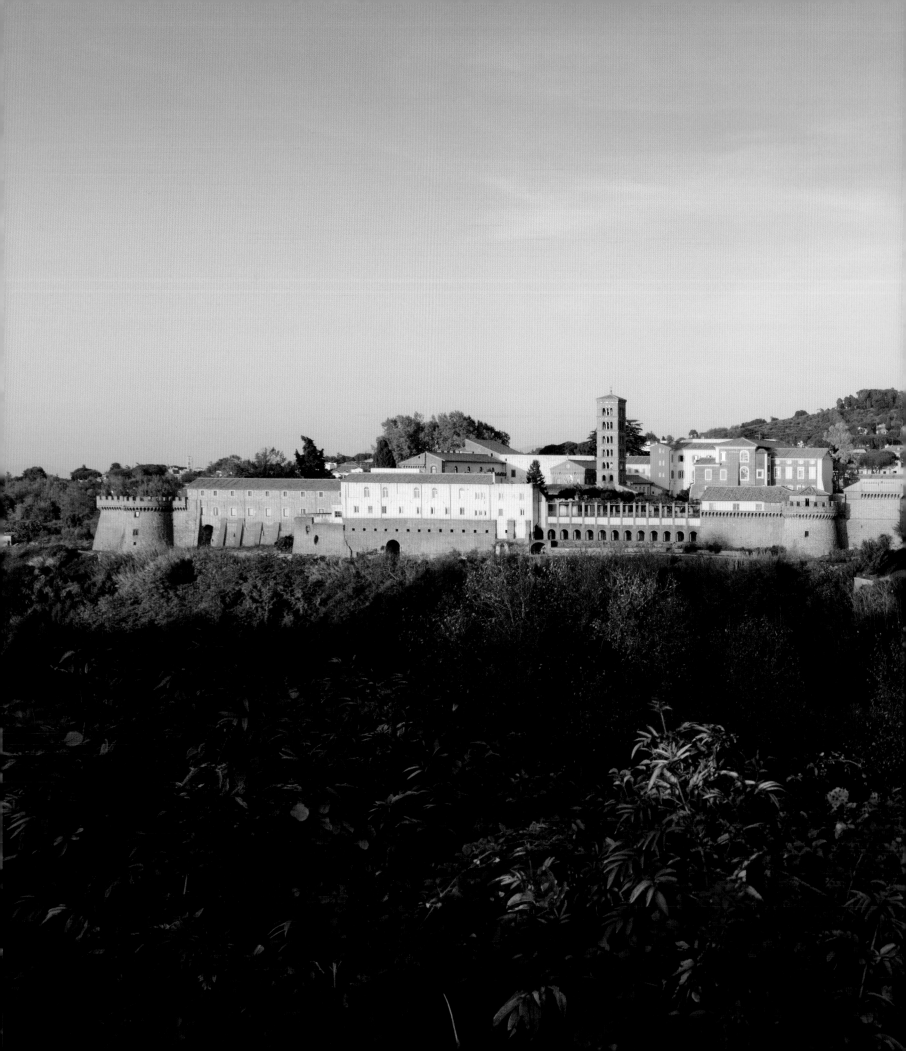

The Grand Traiano Art Complex is a new venue for contemporary art planned for Grottaferrata, a historic town close to Frascati in the hills south of Rome. The complex will contrast existing buildings—in particular a small palazzo on axis with a formal gateway—with new cubic pavilions set amid trees and sculptures in an extensive walled garden.

The Grand Traiano project is undertaken by the Depart Foundation, an initiative by art collectors Pierpaolo and Valeria Barzan to foster emerging art forms and to actively engage in international cultural discourse. "Depart" stands for the Discussion, Exhibition, and Production of Art. The foundation's promotion of contemporary art has evolved from a concern that Rome, so rich in history and so inspirational to generations of artists, has become peripheral to current cultural debate and production.

"The core of Depart Foundation's mission," Pierpaolo Barzan has explained, "is to serve as a catalyst for activating cultural communities through sponsorship of young and established artists by providing them the opportunity to produce new work in the context of Italian history and contemporary culture."[1] The collection already includes work by such American artists as Trenton Doyle Hancock and Roxy Paine.

The site in Grottaferrata is close to the center of town, adjacent to the Exarchic Greek Abbey of St. Mary, a community of Byzantine Greek monks founded in 1004, and next to an outdoor sports field. From the principal gateway, a public path leads between rows of pines to the eighteenth-century villa. The villa was reconfigured in the early twentieth century and additional structures erected when the property served as a hotel. The hotel was frequented at mid-century by a fashionable clientele. The artist Cy Twombly had his first Italian studio here after relocating from the United States in 1957.

The villa is now in need of radical reconstruction. Other existing structures to be retained include a low-rise brick carriage house south of the villa, unfinished blocks to the east and north, an abandoned hotel annex, and a swimming pool with terrace to the northeast. Photographs from the 1960s and '70s show the pool area to have been a busy locus of activity for the resort hotel.

The property is L-shaped with a narrow extension or leg, currently occupied by dilapidated greenhouses, connecting to a local road to the south, next to the municipal sports field. There is also pedestrian access from the north and east and two vehicular access points to the south. It is intended that the park be open and used by the public.

Los Angeles–based architects Sharon Johnston and Mark Lee are responsible for the master plan and for most of the individual buildings. They have built an impressive practice in LA and internationally through frequent collaboration with fellow architects, artists, and curators. For Grottaferrata, Johnston Marklee have designed the campus pursuing an idea of "curatorial urbanism." They propose to renovate the old villa as office or studio space for creative industries (a haven from the more hectic environment of Rome), to rehabilitate the low brick carriage house as a café and bookshop, and to convert the two unfinished structures as a small hotel and residences, respectively.

New pavilions will be sited between the older orthogonal buildings and around the greater site. Formally, these pavilions are compositions of cubic volumes set at oblique

angles and punctured by generous windows. They include a main gallery southeast of the villa, a creative office building next to the pool, and several smaller pavilions set within the park. The gallery comprises four cubic volumes connected one to the next at corners and hinged around an implied patio. The creative building is three stories high with three wings per floor stacked and rotated one above the other. Intermediary roofs slope as exposed, fifth facades within the assembly.

These new structures are envisioned as unadorned brick, picking up on the existing palette; however, they are energized by non-orthogonal planning, rotation, and the carving of space. The architects state that these elemental building blocks are isolated, clustered, hinged or stacked, to form small- and medium-scaled islands of activities.

The morphology of the new architecture thus adjusts itself in response to context and in order to harbor exterior space.

Where the site extends south to reach the secondary road and embrace the sports field, Basel architects HHF propose to demolish the ruined glasshouses and erect a four-story housing complex, a linear set of towers assembled from elemental building blocks. These units, punctured by large windows and by double-height interior spaces, may be rented, sold, or allocated to artists-in-residence. An underground parking garage will be inserted between the existing structures.

The Berlin-based landscape architecture practice Topotek 1 is responsible for redesigning the landscape. They propose to overlay stone pathways through the park at Grottaferrata and to surround the principal buildings in abstract brick patterns. Magnolias, palms, and cypresses will complement the pines.

When completed, the Grand Traiano Art Complex will have reinterpreted the classical estate or park, integrating the institution into the life of the town, with many possibilities not only for the installation but for the creation of art.

The Depart Foundation is also working with Johnston Marklee to expand a winery at Poggio Golo in the Montepulciano region north of Rome. That project includes production facilities, a wine shop and a tasting room, and interior and exterior exhibition spaces for art. To preserve and enhance views, the design aims to be minimally invasive.

Johnston Marklee plan to integrate the new building into the existing promontory. Visitors will approach from the roof and descend into an open courtyard with remarkable views to the vineyard. The rusticated brick exterior of the new construction reflects local architectural tradition, construction methods, and artisanship. Sustainable practices include the building's materials, massing, and siting as well as the use of solar energy and water reclamation systems.

"It's a very contemporary building," says Barzan. "It's a work of art in itself, but it blends well with the landscape. Being modern doesn't mean that it's out of the context. You can have good or bad architecture no matter if it's modern or old."[2]

The bifurcated form of Johnston Marklee's design consists of three connected wings—one entrenched in the hill, the other two sloping to bracket a patio clad in travertine. In this patio, French artist Daniel Buren proposes to erect vividly colored monoliths in a reflecting pool and to line inner courtyard elevations with mirrored glass to amplify the sculpture, sky, and landscape, Poggio Golo will also have an artist-in-residence program. Thus the production of wine is united with Depart's goal to foster visual culture in a subtly contemporary building.

→ View of the town of Grottaferrata from a neighboring hill, capturing monastery (left) and construction crane for Grand Traiano Art Complex visible (right)

1 Pierpaolo Barzan, quoted in *Later Layer* (Grottaferrata, Italy: A Depart Publication, 2010), 7.
2 Barzan, quoted in Jennifer Fiedler, "Italian Tech Mogul Pierpaolo Barzan," *Wine Spectator*, March 9, 2010, http://www.winespectator.com/webfeature/show/id/42289.

The core of Depart Foundation's mission is to serve as a catalyst for activating cultural communities through sponsorship of young and established artists by providing them the opportunity to produce new work in the context of Italian history and contemporary culture.

Pierpaolo Barzan, *Art Collector and Founder*

↗ Top: View through entrance to Grand Traiano Art Complex

Middle: Existing interior of villa

Bottom: Existing state of the swimming pool and surroundings

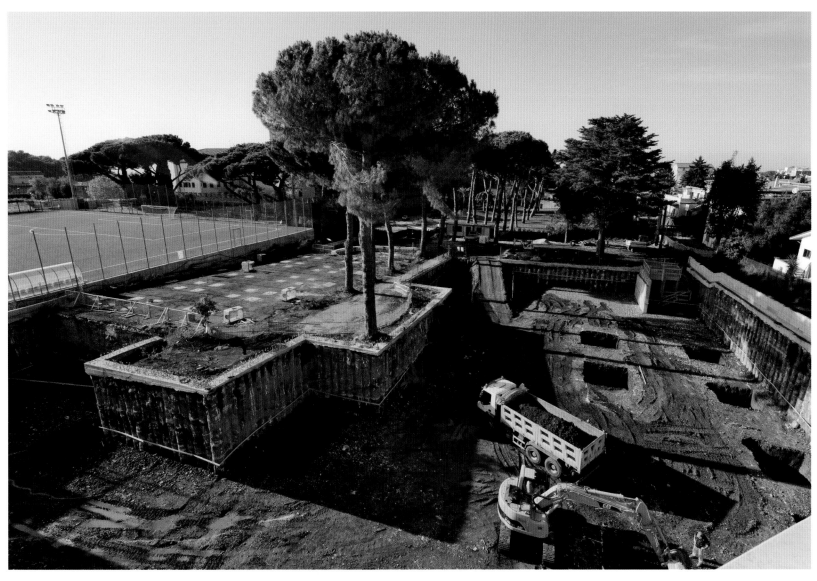

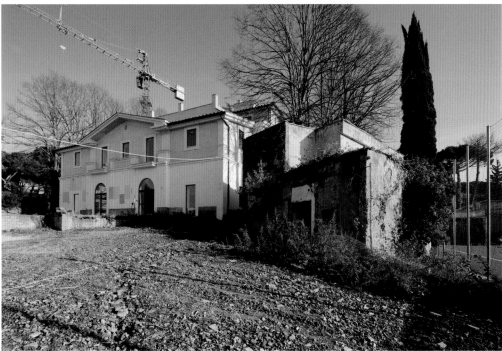

↑ View over initial construction on underground parking garage

← Front facade of old Grand Traiano Hotel

↑ Top: Rendering by landscape architects
Topotek 1 of the Grand Traiano Art Complex
with artworks and pavilions

Bottom: Interior rendering by Johnston
Marklee of the Grand Traiano Museum
Building

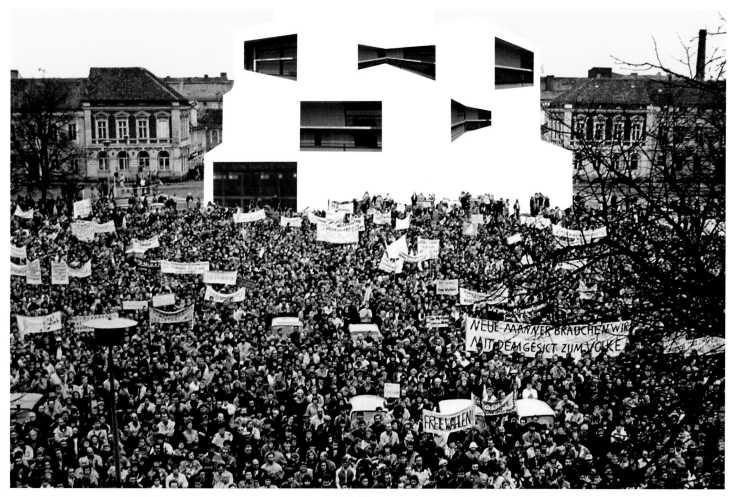

↑ Top: Collage by Johnston Marklee of the Grand Traiano Commercial Building

Bottom left: Collage by Johnston Marklee of the Grand Traiano Museum Building

Bottom right: Photomontage by HHF of new Grand Traiano housing complex

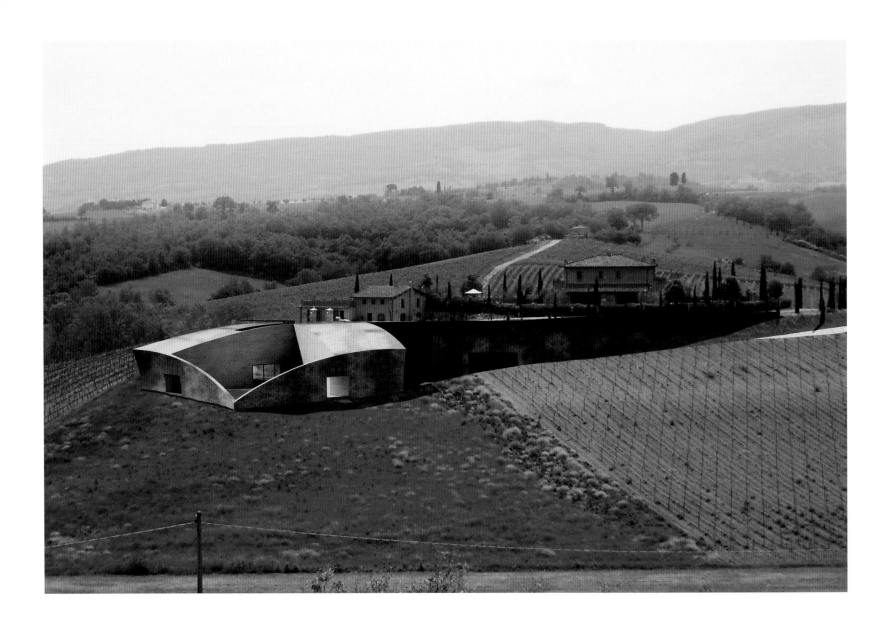

↑ Rendering by Johnston Marklee of
proposed extension to the Poggio Golo
winery in Montepulciano

Pool: Black & white
Pillars: 4 colors –

↖ Top: Collage by Johnston Marklee of the courtyard at the Poggio Golo winery

Bottom: Rendering depicting Daniel Buren installation in new courtyard at Poggio Golo

↑ Preparatory sketch for installation by Daniel Buren at Poggio Golo

Name of Institution
Grand Traiano Art Complex

Area
2.2 hectares (5.4 acres)

Dates
Construction to begin: 2014
(Grottaferrata) and 2015 (Poggio
Golo)

Client
Depart Foundation

Pierpaolo and Valeria Barzan,
Founders

Location
Grottaferrata, Lazio, Italy

(Winery at Poggio Golo,
Montepulciano, Tuscany, Italy)

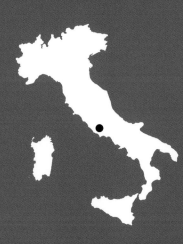

Architects
Johnston Marklee
Sharon Johnston, Mark Lee
Los Angeles, Californa

HHF architects
Tilo Herlach, Simon Hartmann,
Simon Frommenwiler
Basel, Switzerland

Landscape Architect
Topotek 1
Martin Rein-Cano, Lorenz Dexler
Berlin, Germany

Key Artists

Richard Aldrich

Darren Almond

Walead Beshty

Daniel Buren (at Poggio Golo site)

Michael Cline

Roe Ethridge

Lucas de Giulio

Trenton Doyle Hancock

Valerie Hegarty

Sawa Hiraki

Christian Holstad

Ben Jones

Roxy Paine

Ester Partegàs

Stephen G. Rhodes

Amanda Ross-Ho

Sterling Ruby

Simmons & Burke

Susanne M. Winterling

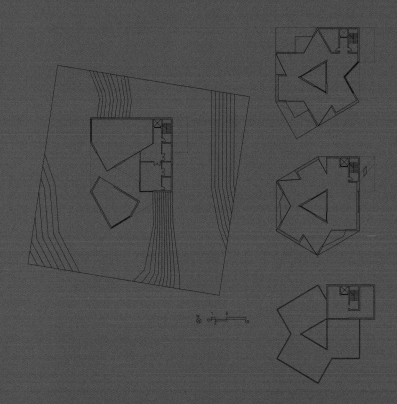

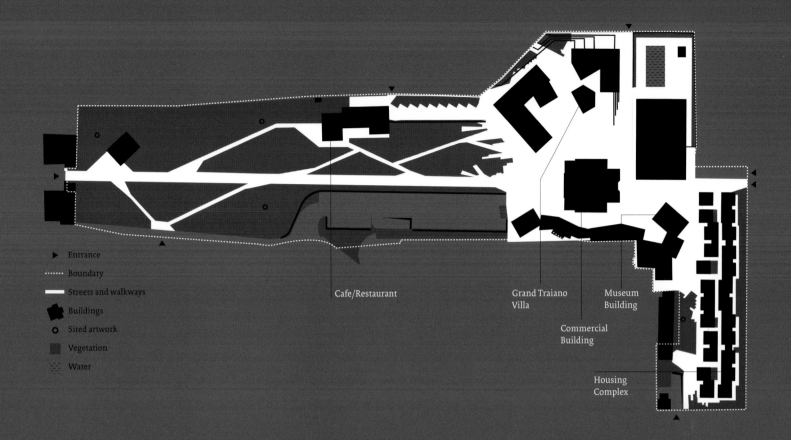

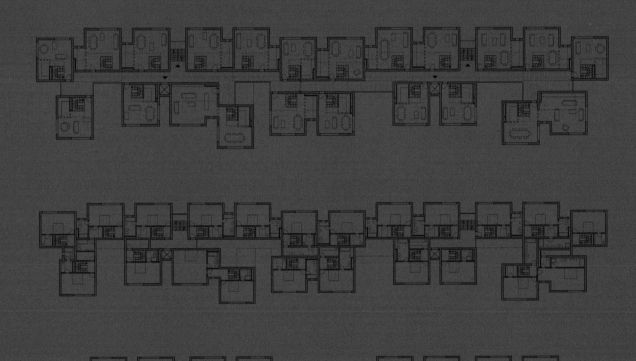

Entrance
Boundary
Streets and walkways
Buildings
Sited artwork
Vegetation
Water

Cafe/Restaurant

Grand Traiano
Villa

Museum
Building

Commercial
Building

Housing
Complex

↖ Top: Historic photograph of Grand
Traiano Hotel entrance

Middle: Historic photograph of
Grand Traiano Hotel swimming pool

Bottom: Floor plans by Johnston
Marklee of Commercial Building at
Grand Traiano Art Complex

→ Top: Site plan of Grand Traiano Art
Complex

Bottom: Plans by HHF of Housing
Complex at Grand Traiano Art
Complex

Selected Bibliography

Baan, Iwan, and Cees Nooteboom. *Iwan Baan, Brasilia–Chandigarh: Living with Modernity*. Baden: Lars Müller, 2010.

Baan, Iwan, and Florence Sarano. *Iwan Baan autour du monde: Journal d'une année d'architecture/Iwan Baan around the World : Diary of a Year of Architecture*. Hyères: Villa Noailles, 2011.

Moore, Rowan, and Raymund Ryan. *Building Tate Modern: Herzog & De Meuron Transforming Giles Gilbert Scott*. London: Tate Gallery, 2000.

O'Doherty, Brian. *Inside the White Cube: The Ideology of the Gallery Space*. Berkeley: University of California Press, 1999.

———. *Studio and Cube: On the Relationship between where Art Is Made and where Art Is Displayed*. New York: Temple Hoyne Buell Center for the Study of American Architecture, 2007.

Ryan, Raymund. "New Frontiers." *tate*, no. 21 (2000).

Treib, Marc. *Settings and Stray Paths: Writings on Landscapes and Gardens*. London: Routledge, 2005.

———. *Space Calculated in Seconds: The Philips Pavilion, Le Corbusier, Edgard Varèse*. Princeton, NJ: Princeton University Press, 1996.

———, ed. *Modern Landscape Architecture: A Critical Review*. Cambridge, MA: MIT Press, 1993.

Olympic Sculpture Park

Busquets, Joan, ed. *Olympic Sculpture Park for the Seattle Art Museum*. Cambridge, MA: Harvard University Graduate School of Design, 2008.

Corrin, Lisa Graziose, Chris Rogers, Marion Weiss, and Michael Manfredi. *Olympic Sculpture Park*. Seattle, WA: Seattle Art Museum, 2007.

Manfredi, Michael A., and Marion Weiss. *Weiss/Manfredi: Surface/Subsurface*. New York: Princeton Architectural Press, 2008.

Reed, Peter. *Groundswell: Constructing the Contemporary Landscape*. New York: Museum of Modern Art, 2005.

Stiftung Insel Hombroich

"Concrete for Art: Concrete Technology at the Musician's House at Insel Hombroich." *Opus C*, no. 2 (2009): 30–33.

Finsterwalder, Rudolf, and Wilfried Wang, eds. *From Line to Space*. Vienna: Springer, 2011.

Heerich, Erwin, Joachim P. Kastner, and Walter Zschokke. *Museum Insel Hombroich*. Stuttgart: Hatje, 1996.

Langen-Crasemann, Sabine, Chrysanthi Kotrouzinis, and Renate Ubrig, eds. *Langen Foundation*. Hamburg: Dürmeyer GmbH, 2006.

Wang, Wilfried, ed. *Hombroich: spaceplacelab*. Neuss: Stiftung Insel Hombroich, 2004.

Benesse Art Site Naoshima

Ando, Tadao. "A Powerful Message from Naoshima." *Naoshima Note*, no. 3 (2011).

Hasegawa, Yuko, and Kazuyo Sejima. *People Meet in Architecture: Catalogo Ufficiale*. Venice: Marsilio, 2010.

Hashimoto, Jun, ed. "Inujima Art Project Seirensho." *Japan Architect 81: Hiroshi Sambuichi*, no. 81 (2011): 70–91.

Jodidio, Philip, and Tadao Ando. *Tadao Ando at Naoshima: Art, Architecture, Nature*. New York: Rizzoli, 2006.

Müller, Lars, Akiko Miki, and Iwan Baan. *Insular Insight: Where Art and Architecture Conspire with Nature: Naoshima, Teshima, Inujima*. Baden: Lars Müller, 2011.

Ryan, Raymund. "Teshima Art Museum." *Domus* 942 (2010): 48–57.

Instituto Inhotim

Montero, Marta I., and R. Burle Marx. *Roberto Burle Marx: The Lyrical Landscape*. Berkeley: University of California Press, 2001.

Pagliari, Francesco. "Inhotim Contemporary Art Center: Brumadinho, Brazil." *The Plan: Architecture & Technology in Detail* 49 (2011): 78–96.

Pedrosa, Adriano, and Rodrigo Moura, eds. *Através: Inhotim Centro de Arte Contemporânea*. Brumadinho, Brazil: Instituto Cultural Inhotim; Belo Horizonte, Brazil: Rona, 2008.

Ruiz, Cristina. "Where Dreams Come True." *Art Newspaper* 218 (November 2010), http://www.theartnewspaper.com/articles/where-dreams-come-true/21858.

Serapião, Fernando, ed. "Inhotim: Art, Architecture and Landscape." *Monolito* 4 (2011).

Jardín Botánico de Culiacán

"Ai Weiwei, Luis Aldrete, Christ & Gantenbein AG Architekten, Dellekamp Arquitectos, Elemental, Godoylab, HHF architects, Omar Orlaineta, Periferica, Tatiana Bilbao,Taller TOA: Route of Pilgrim, from Ameca to Talpa de Allende, Jasco, Mexico 2008–." *A + U: Architecture and Urbanism* 9480 (2010): 24–37.

Alonso, Idurre, Susan Golden, and Martha Guzmán, eds. *Mexico: Expected/Unexpected*. Long Beach: Museum of Latin American Art; La Jolla: Museum of Contemporary Art San Diego, 2011.

Ryan, Raymund. "Observatory House, Puerto Escondido, Mexico: Gabriel Orozco & Tatiana Bilbao." *The Plan* 35 (2009): 66–76.

Grand Traiano Art Complex

DeGennaro, James, and Amanda Jones, eds. *Graduate Sessions 5: Johnston Marklee*. Syracuse: Syracuse University School of Architecture, 2007.

Folkerts, Thilo, ed. *Topotek 1, Martin Rein-Cano, Lorenz Dexler, Rosemarie Trockel: A Landscape Sculpture for Munich*. Basel: Birkhäuser, 2011.

Geiser, Reto, ed. *House Is a House Is a House Is a House: Architectures and Collaborations of Johnston Marklee*. Vienna: Springer, 2012.

HHF architekten. *HHF Architects Paper*, no. 1 (2010).

Johnston Marklee and Walead Beshty. *Later Layer*. Grottaferrata, Italy: Depart Foundation, 2010.

Index of Names

Photography Credits

Many of the images in this publication are protected by copyright and may not be available for further reproduction with out permission of the copyright holder. Every reasonable attempt has been made to identify owners of copyright. Errors or omissions will be corrected in subsequent editions.

Unless otherwise noted, all photographs are © Iwan Baan.

The following credits apply to all images for which separate acknowledgment is due.

Ryan

p. 13, fig. 1: © Estate of Robert Smithson/Licensed by VAGA, New York, NY; p. 14, fig. 2: Photo: Douglas Tuck, 2009, courtesy of the Chinati Foundation. Art © Judd Foundation. Licensed by VAGA, New York, NY; p. 14, fig. 4: Photo: Andrew Lawson; p. 14, fig. 5: Visual Resources Collection, Art, Architecture and Engineering Library, University of Michigan. Photo: Edward Olencki; p. 15, fig. 6: Photo: Mary Ann Sullivan; p. 15, fig. 7: © Herzog & de Meuron; p. 16, fig. 8: Courtesy David Hotson; p. 16, fig. 9: Courtesy Weiss/Manfredi; p. 16, fig. 10: Photo: Tomas Riehle; p. 17, fig. 11: © Hiroshi Sugimoto, courtesy The Pace Gallery; p. 18, fig. 12: Photo: Daici Ano. Courtesy Architects Atelier Ryo Abe; p. 19, fig. 14: © Adrian Gaut/Art + Commerce.

Treib

All photographs © Marc Treib. p. 23, fig. 10: © 2012 Richard Serra/Artists Rights Society (ARS), New York; p. 23, fig. 11: © 2012 The Isamu Noguchi Foundation and Garden Museum, New York/Artists Rights Society (ARS), New York.

Olympic Sculpture Park

pp. 24, 27: © 2012 Richard Serra/Artists Rights Society (ARS), New York; p. 29 (bottom): Courtesy Weiss/Manfredi; p. 32 (top): Seattle Art Museum, Gift of Sally and William Neukom, American Express Company, Seattle Garden Club, Mark Torrance Foundation and Committee of 33, in honor of the 75th Anniversary of the Seattle Art Museum; p. 35 (bottom): Courtesy Roy McMakin; p. 36: Courtesy Weiss/Manfredi; p. 37 (bottom left): Seattle Municipal Archives Item # 10494; p. 37 (bottom right): Seattle Art Museum, PONCHO and the Mark Tobey Estate Fund, in honor of the 75th Anniversary of the Seattle Art Museum © Glenn Rudolph.

Stiftung Insel Hombroich

p. 48: Álvaro Siza, Archive; p. 50: Estate of Raimund Abraham; p. 51 (top and bottom): Courtesy Oliver Kruse; p. 53 (bottom): Photo: Terushi Jimbo.

Benesse Art Site Naoshima

p. 61: © Hiroshi Sugimoto, courtesy The Pace Gallery; pp. 64 (bottom) and 65: Courtesy Yukinori Yanagi; p. 71 (bottom): Photo courtesy of Keiko Arimoto.

Instituto Inhotim

p. 80 (bottom): © Matthew Barney. Courtesy the artist and Gladstone Gallery, New York and Brussels; p. 81 (bottom): Courtesy Chris Burden; pp. 82–83: Courtesy 303 Gallery, New York; p. 84 (middle left): Courtesy Marila Dardot; p. 85 (bottom left): Courtesy Doris Salcedo; p. 86 (top right): Courtesy Instituto Inhotim, Minas Gerais, Brazil; p. 87 (top): Courtesy Arquitetos Associados.

Jardín Botánico de Culiacán

p. 92: Courtesy TOA; p. 94: Courtesy Dan Graham; pp. 96–97: © Olafur Eliasson. Courtesy Marian Goodman Gallery; p. 102 (left): Courtesy Tatiana Bilbao; p. 102 (right): Photo: Tatiana Bilbao, courtesy Tatiana Bilbao; p. 103 (top): Courtesy Tatiana Bilbao.

Grand Traiano Art Complex

p. 110 (top): Courtesy Topotek 1; p. 110 (bottom): Courtesy Johnston Marklee; p. 111 (top and bottom left): Courtesy Johnston Marklee; p. 111 (bottom right): Courtesy HERLACH HARTMANN FROMMENWILER with Janna Jessen, Lukas Kupfer, Mio Tsuneyama; p. 112: Courtesy Johnston Marklee; p. 113: Courtesy Johnston Marklee; p. 114: Photos courtesy Grottaferrata Nostra; p. 115 (bottom): Courtesy HERLACH HARTMANN FROMMENWILER with Janna Jessen, Lukas Kupfer, Mio Tsuneyama.

Cover Images

(All photographs by Iwan Baan)

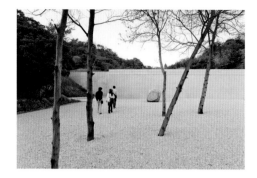 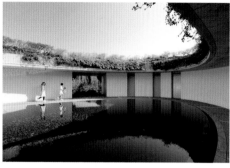

← Left: Forecourt of Lee Ufan Museum by Tadao Ando, Naoshima, Japan

Right: Reflecting pool and large oculus in the Benesse House Oval by Tadao Ando, Naoshima, Japan

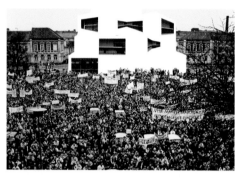 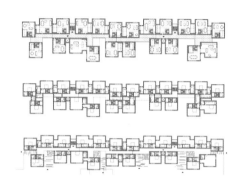

← Left: Collage by Johnston Marklee of the Grand Traiano Commercial Building, Grand Traiano Art Complex, Grottaferrata, Italy

Right: Plans by HHF of new housing complex, Grand Traiano Art Complex, Grottaferrata, Italy

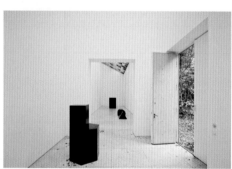 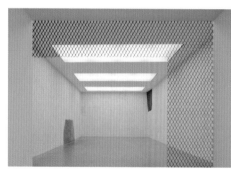

← Left: Interior of the Hohe Galerie with sculptures by Erwin Heerich, Insel Hombroich, Germany

Right: Interior of Doris Salcedo's installation *Neither* (2004), Instituto Inhotim, Brazil

 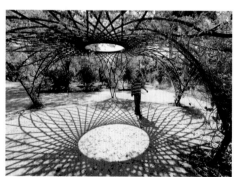

← Left: Exterior of PACCAR Pavilion by Weiss/Manfredi with Roxy Paine's *Split* (2003) in foreground, Olympic Sculpture Park, Seattle

Right: View of Olafur Eliasson's *The Flower Archway* (2005), Jardín Botánico de Culiacán, Mexico

Olympic
Sculpture Park

Jardín Botánico
de Culiacán

Instituto
Inhotim